Bonfires & Beacons

GREAT LAKES LIGHTHOUSES

Bonfires & Beacons

GREAT LAKES LIGHTHOUSES

L A R R Y & P A T R I C I A W R I G H T

The BOSTON
MILLS PRESS

To my parents,
who inspired me to become a lifelong learner.
— P.W.

CANADIAN CATALOGUING IN PUBLICATION DATA

Wright, Larry, 1949–
Bonfires & Beacons: Great Lakes Lighthouses

ISBN 1-55046-185-0

1. Lighthouses – Great Lakes – Pictorial works.
2. Lighthouses – Great Lakes – History. I. Wright,
Patricia, 1949– . II. Title.

VK1023.3.W75 1996 387.1'55'0977 C97-930707-1

Design by Gillian Stead
Printed in Hong Kong by
Book Art Inc., Toronto

First published in 1996 by
THE BOSTON MILLS PRESS
132 Main Street
Erin, Ontario, Ontario
N0B 1T0
Tel 519-833-2407
Fax 519-833-2195

An affiliate of
Stoddart Publishing Co. Limited
34 Lesmill Road
North York, Ontario, Canada
M3B 2T6

BOSTON MILLS BOOKS are available for bulk purchase for sales promotions, premiums,
fundraising, and seminars. For details contact:

SPECIAL SALES DEPARTMENT, Stoddart Publishing Co. Limited, 34 Lesmill Road,
North York, Ontario, Canada M3B 2T6 Tel 416-445-3333 Fax 416-445-5967

CONTENTS

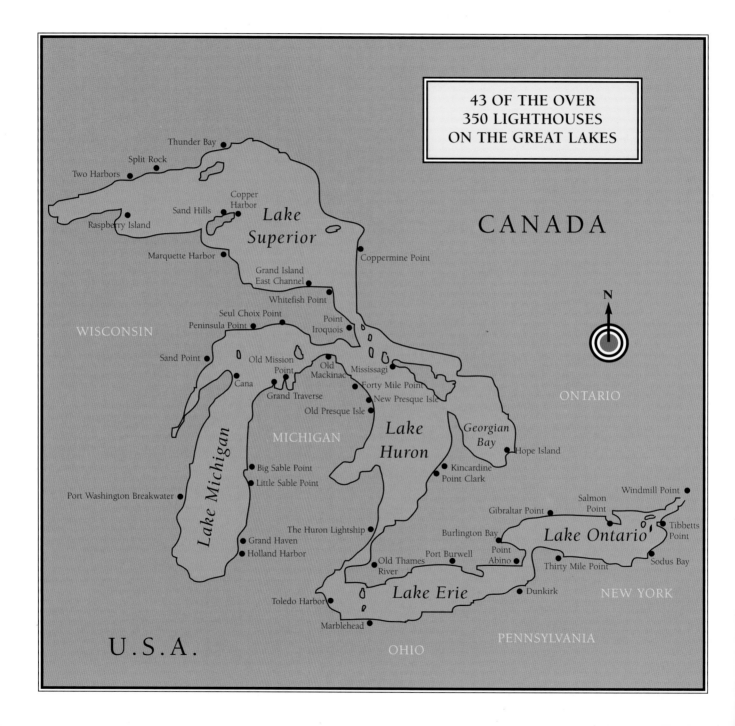

43 OF THE OVER 350 LIGHTHOUSES ON THE GREAT LAKES

N

CANADA

Lake Superior

Thunder Bay
Split Rock
Two Harbors
Raspberry Island
Sand Hills
Copper Harbor
Marquette Harbor
Grand Island East Channel
Whitefish Point
Coppermine Point

WISCONSIN

ONTARIO

Seul Choix Point
Peninsula Point
Point Iroquois
Sand Point
Old Mission Point
Cana
Old Mackinac
Mississagi
Grand Traverse
Forty Mile Point
New Presque Isle
Old Presque Isle

MICHIGAN

Lake Michigan

Lake Huron

Georgian Bay
Hope Island

Big Sable Point
Little Sable Point
Port Washington Breakwater

Kincardine
Point Clark

Windmill Point
Salmon Point
Gibraltar Point
Lake Ontario
Tibbetts Point

The Huron Lightship
Burlington Bay
Point Abino
Grand Haven
Holland Harbor
Port Burwell
Thirty Mile Point
Sodus Bay

Old Thames River

Toledo Harbor
Dunkirk
NEW YORK

Lake Erie

Marblehead

U.S.A.

OHIO
PENNSYLVANIA

INTRODUCTION

About twenty-two years ago my husband, Larry, first started to take pictures of lighthouses on Georgian Bay with his friend and mentor, Bud Watson, a renowned Canadian photographer. Ten years later Larry went back to rephotograph some of these lighthouses, only to discover that many had been torn down, burned or left in ruin. His previous photographs began to take on new meaning. As a result, Larry decided that he would attempt to record the history of Georgian Bay lighthouses. This idea grew to include the lighthouses of the Great Lakes. I agreed to assist him with the research and writing, and the evolution of this book began. It has been a satisfying and rewarding experience, one that we have both enjoyed.

Navigation on the seas has always been dangerous. In early times, without aids to navigation, shipwrecks were common and deadly. Families soon began to light bonfires on hilltops or along shorelines so their fishing boats could find their way home after dark. In later centuries, shore pirates would take advantage of this practice. They would light their own bonfires to lure ships onto rocky shores and then loot the wrecks.

With the increase in trade and the need to protect warships, it became necessary to develop better ways of marking the shoreline and the shoals. The lights changed from bonfires to hanging firepots, then to lanterns in trees or fire in barrels. The open fires were used as night beacons, but during the day the smoke from these fires would also signal danger. Smaller fires, torches and lanterns served to signal harbor entrances.

One of the Seven Wonders of the Ancient World was the Pharos in Alexandria, built in about 280 B.C. to guide ships into the Nile River. It stood over 400 feet (122 m) high, but fell into ruins during an earthquake in the early 1300s. Pharos came to mean lighthouse; today pharology refers to the science of lighthouse construction.

Today the Great Lakes make up the world's largest inland waterway. These five lakes, Lakes Superior, Michigan, Huron, Erie and Ontario, cover over 95,000 square miles (246,000 km²) of navigable water and have about 8,000 miles (12,900 km) of shoreline. They are bordered by one Canadian province and eight American states. These lakes contain some of the most treacherous waters to navigate in the world; there are hidden rocks and shoals, jagged coastlines, deadly storms, swift currents and shifting sand bars.

As commerce and shipping grew in the Great Lakes region, the Canadian government approved the building of three lighthouses. The first was to be built at Mississauga Point at the mouth of the Niagara River, the second at Gibraltar Point at Fort York (now Toronto), and the third on Isle Forest near Kingston. The Mississauga light was completed in 1804 and manned by a soldier from Fort George. In 1818 the first two

American lighthouses on the Great Lakes were built, one at Buffalo, New York, and the other at Presque Isle on Lake Erie.

There are various styles of lighthouses on the Great Lakes, from short wooden towers to tall stone or brick towers over 100 feet (30 m) high. Skeletal towers and pier towers mark some harbors and remote islands. The height of a tower depended on the chosen site and the purpose of the light. Low land requires a tall tower, but a high cliff needs only a short lighthouse. The light shines horizontally across the water, and the height of that light above the water is referred to as the focal plane. The higher the focal plane and the brighter the light, the greater the range of visibility.

At night and in fog, lights would warn sailors of rocky shoals or dangerous coastlines. Each light had its own distinctive flash pattern, which enabled sailors to identify the lighthouse on their charts and thereby fix their exact location. Lighthouses also provided a visual reference in daytime; some were even specially painted so that they could be easily recognized.

In the 1700s, light was provided by candles. The intensity of a light is still measured in terms of candle-power. By the 1800s oil-burning lamps were used. These would burn a variety of oils, but most commonly used whale oil and lard. The best of the oil lamps was the Argand lamp, which burned hollow wicks that produced a bright, smokeless flame. By 1855, kerosene, invented by Abraham Gesner in Nova Scotia in 1846, was cheap, reliable and efficient and had replaced whale oil (by then difficult to obtain) as the most popular fuel for lighthouses. After this time, acetylene was also employed.

At first, light sources were intensified in one of two ways. A catoptric system used a polished parabolic reflector to disperse the light; a dioptric system used simple lenses to intensify the light beam. But in 1822, Jean Fresnel, an optical engineer from France, invented a new lens. The Fresnel lens was an intricately arranged beehive-like pattern of lenses and prisms that surrounded the light source. This lens reflected and refracted the light to produce a single, high-intensity horizontal beam for greater visibility. This system of refracting prisms and concentrating lenses is known as a catadioptric system.

Fresnel lenses were available in seven different orders, varying in size and magnification. The first-order lens was about 8 feet (2.5 m) high; a sixth-order lens was about a fifth of that size. First- and second-order lenses were used as coast lights, while the smaller ones were used as markers for harbors and shipping lanes. Fresnel lenses began to be used in lighthouses on the Great Lakes in the late 1800s.

By that time the revolving light mechanisms were floated in mercury and driven by a clockwork system with heavy weights that had to be wound by the lightkeeper every two to four hours. In the early 1900s, lights began to be powered by electricity. By the 1930s most lighthouses had been converted to electricity. Full automation soon followed, with timer switches and multiple-bulb holders that automatically replaced burned-out lightbulbs. This reduced the need for lightkeepers.

Today's functioning lighthouses are powered by electricity, batteries or solar energy and only require routine checks every spring and fall. Modern mercury-vapor and xenon bulbs are so powerful that simple optics of pressed glass or plastic have replaced the Fresnel lenses in many lighthouses. Standard white lights warn of danger, and red and green lights aid with navigation and outline harbor entrances.

Many of the lighthouses on the Great Lakes had fog-signal stations, each of which had its own distinctive signal. The first American fog signal was a cannon used at the Boston light in 1719. Fog bells were introduced in the early 1800s, and by around 1860 mechanisms were installed to ring them mechanically. By the 1920s some fog-signal stations used an electrically operated bell and a device called a hydroscope, which automatically started the sounding equipment when fog arose. During the 1850s fog whistles and trumpets powered by compressed air were used, but with limited success. Steam whistles were also experimented with, and once their size was increased, were used successfully into the twentieth century.

Today sirens, diaphones and diaphragm horns and, occasionally, bells are still used. Sirens were introduced as fog signals during the 1860s. The diaphone, an invention of the Canadian Lighthouse Service, is a piston-operated device powered by compressed air which produces a sound signal audible up to 12 miles (19.5 km) away under favorable conditions. Diaphragm air signals employ a metal diaphragm (usually bronze) that vibrates in a resonator.

The most recent type of fog signal, and one that neighbors of lighthouses have come to appreciate, is the radio beacon. The radio beacon is especially useful during reduced visibility and also aids in navigation.

With the advent of radar and satellite navigational systems, lighthouses have become less significant to large shipping. However, some lake-freighter captains still take comfort in seeing the lights, and small craft certainly still rely heavily on lighthouses.

Lighthouse keepers have always been a brave and dedicated crew. They have weathered the worst of storms and rescued countless seamen in distress. One regulation stipulated that a lightkeeper must make at least three rescue attempts. More than a job, lighthouse-keeping was a way of life. The lighthouses featured in this book evoke the rugged beauty and rich history of Great Lakes lightkeeping.

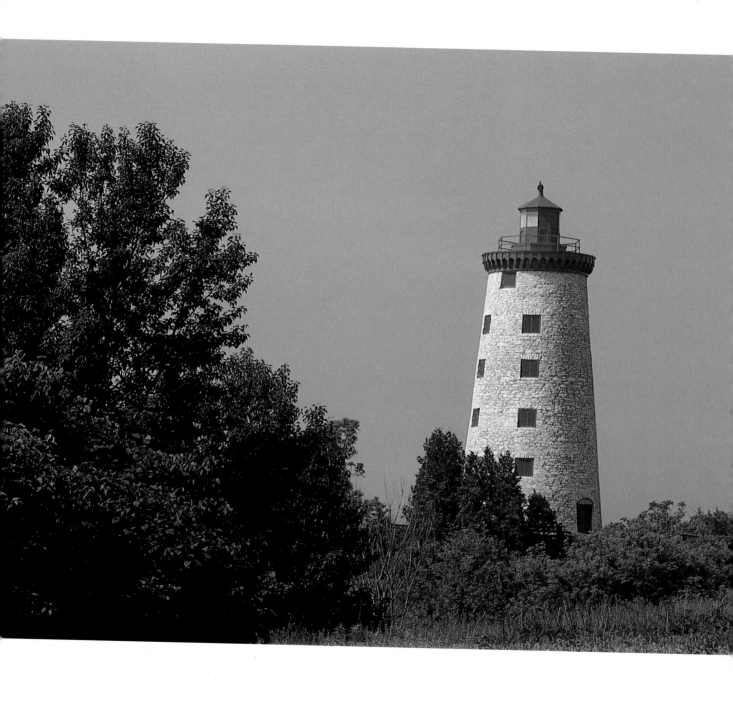

Windmill Point

ONTARIO

The Windmill Point lighthouse was first constructed in 1820 as a functioning windmill to service the local farming community along the shore of the St. Lawrence River. It is famous as the location of the Battle of the Windmill, fought around its base in 1838, during the Canadian Rebellion, or Patriot War.

Canadian rebels and American sympathizers fought to overthrow Fort Wellington and thereby liberate Canada from British rule. The British and Loyalists battled to protect their homes and the established political order of Fort Wellington and the region. The British learned of the rebel plans and, along with the local militia, surrounded the renegades at Windmill Point. After four days and much bloodshed, the battle ended with the defeat of the rebels.

The windmill was converted to a lighthouse in 1872. It remained in service until 1978 and is now considered a National Historic Site. The lighthouse is located just downriver from Prescott on the north shore of the St. Lawrence River. Other points of interest in the Prescott area include the Prescott Harbour, the Stockade Barracks and Hospital Museum (Ontario's oldest barracks), the Homewood Museum, the Forwarder's Museum, the waterfront promenade and Fort Wellington. At the fort, Loyalist history is relived each summer during the ten-day Loyalist Festival. The festival culminates in the Fort Wellington Military Pageant, during which historical reenactors dress in authentically reproduced American Revolutionary War uniforms and stage a mock battle for control of Fort Wellington. In December the fort hosts the garrison Christmas celebrations.

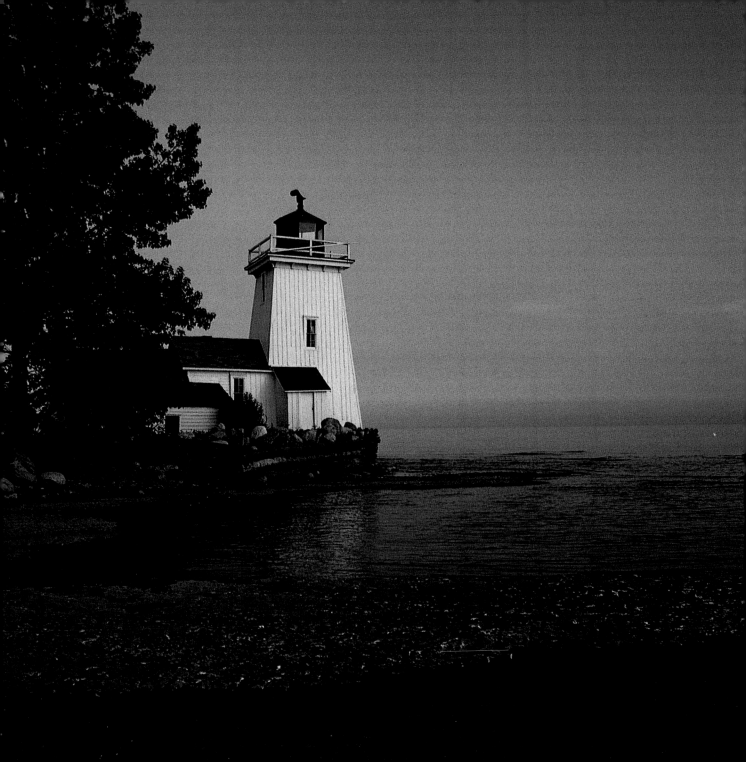

Salmon Point

ONTARIO

This lighthouse was once named the Wicked Point lighthouse, as it warned mariners of some of the most dangerous shoals in the Quinte waters of Lake Ontario. The shoals consist of a spit that extends west–southwest from the point for about 2 1/2 miles (4 km).

Salmon Point lighthouse, a beautiful wooden structure, was erected in 1871 and remained in use until 1917. In 1918 the lighthouse and 100 acres (40 ha) of land were sold by the Crown back to the private sector. The building stands 40 feet (12 m) above sea level and has a white square tower with an attached lightkeeper's dwelling. When in operation, it sent its warning signal from sunset to sunrise during the navigational season.

An 1863 map shows Peter Huff as the earliest owner of Salmon Point. Lights at Point Petre and Huycke's Point were thought to be sufficient guidance for the vessels of the day. However, occasionally some strange attraction seemed to pull the sailing vessels off course and they would crash on the rocky shoals of Salmon Point. The Salmon Point lighthouse was built to avoid such shipwrecks.

According to Mrs. L. Etheyl Brooks, the lightkeepers changed along with local politics. Politics were taken very seriously in those days, and the job of lighthouse keeper was one of the plums for the victorious to hand out. In *Canvas and Steam on Quinte Waters*, Amos MacDonald, the second lightkeeper here, is quoted as saying, "In 1897 the Federal Government notified me of my appointment as lightkeeper at Salmon Point. My instructions were that I should do everything to assist navigation, and for twelve years and one month, while I remained at the post, I attempted to do so. I believe that the lighthouse was put up at that spot, not so much as a guide to navigation, but to overlook the most dangerous reef in the waters."

Although closed as a lighthouse in 1917, the structure remained as a residence in the 1920s and was later used as a summer cottage. For the past fifty-two years it has been owned by the Rankin family, who operate a campground and rent out the lighthouse by the week.

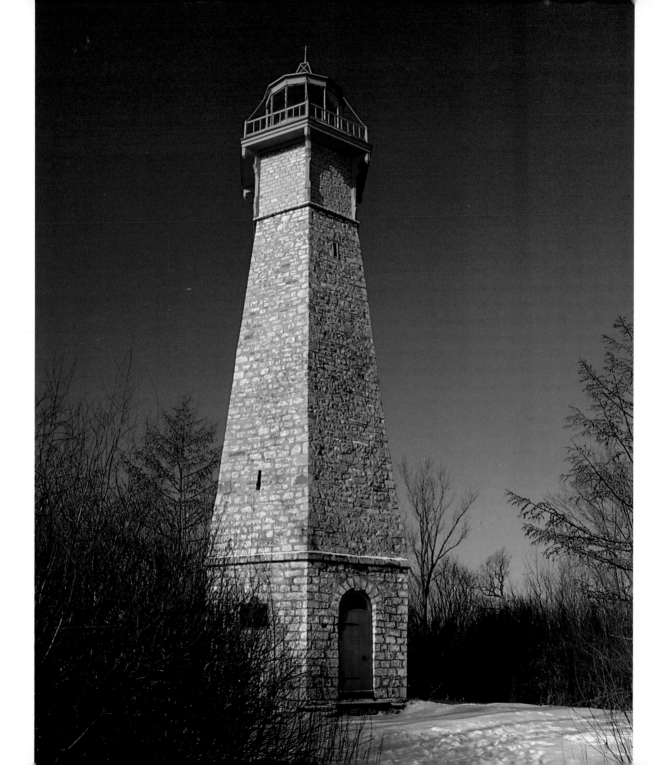

Gibraltar Point

ONTARIO

Because of its large and easily defended harbor, Lieutenant-Governor Simcoe decided to make Fort York the naval and military center of Upper Canada. This site, guarding the harbor, was named Gibraltar Point. Fortification began in 1794, and by 1800 two defensible stone houses and a guard house had been erected.

The Gibraltar Point lighthouse, finished in 1808, was the second lighthouse built on the Great Lakes (the first was the Mississauga lighthouse at Niagara around 1804). Stone for the Gibraltar lighthouse was quarried at Queenston and brought to the site aboard the *Mohawk*.

The first stone building in York (Toronto), this lighthouse is a hexagonal masonry tower with 6-foot-thick (1.8 m) walls. It is tapered up to a height of 52 feet (16 m) and was topped by a wooden cage with a fixed oil lantern that burned about 200 gallons (910 litres) of sperm whale oil per year. A dumbwaiter rose up the middle of the tower and was used to haul whale oil up to the lamp. The light's visibility was about 7 miles (11 km). Attached to the outside of the lantern was a signal hoist used to raise a flag to inform Fort York of incoming vessels.

Lightkeepers and their families were the first civilian residents on the island. The first lightkeeper, John Paul Rademuller, lived in a shuttered pioneer-style frame cottage close to the lighthouse. Rademuller mysteriously vanished in 1815, never to be seen again. There are different explanations for his disappearance. One story goes that on a January night in 1815, soldiers from Fort York visited Rademuller. They became drunk and then beat the lightkeeper to death with their heavy belts when he refused to serve them more liquor. The soldiers escaped along the bay and were never brought to trial. A human skeleton was later found close to the lighthouse, and some believe it was that of Rademuller. Some people also believe that the ghost of J. P. Rademuller still haunts the Gibraltar Point lighthouse.

The Gibraltar Point lighthouse was built 25 feet (7.6 m) from shore, but silt carried in currents from the Niagara River has been deposited at the peninsula. As a result, the land in front of the lighthouse has risen a little bit each year, protecting the lighthouse from erosion. The lighthouse now stands some 300 yards (274 m) from shore. The base rises straight up for about 10 feet (3 m) to a stone outcrop. Above this the tower tapers to 52 feet (16 m), where the addition rises straight up to a hexagonal gallery supported by six red wooden braces. The gallery is topped by a twelve-sided lantern covered by a red dome. Up the tower, instead of regular windows, are long slit openings that may have been rifle ports.

The lighthouse was equipped with a revolving light some time after a further 12 feet (3.7 m) were added at the top in 1832. In 1858 a severe thunderstorm washed away the sand bottleneck and made the peninsula into an island (now called Centre Island). The lighthouse remained in service for 150 years until replaced by a small tower in 1958.

Today the grand stone tower, the oldest standing lighthouse on the Great Lakes, seems to defy the effects of time. A harbor cruise affords a good view of the lighthouse, but to visit it you must travel by ferry to Centre Island and then bike or take the shuttle-train to the lighthouse. It is worth a visit.

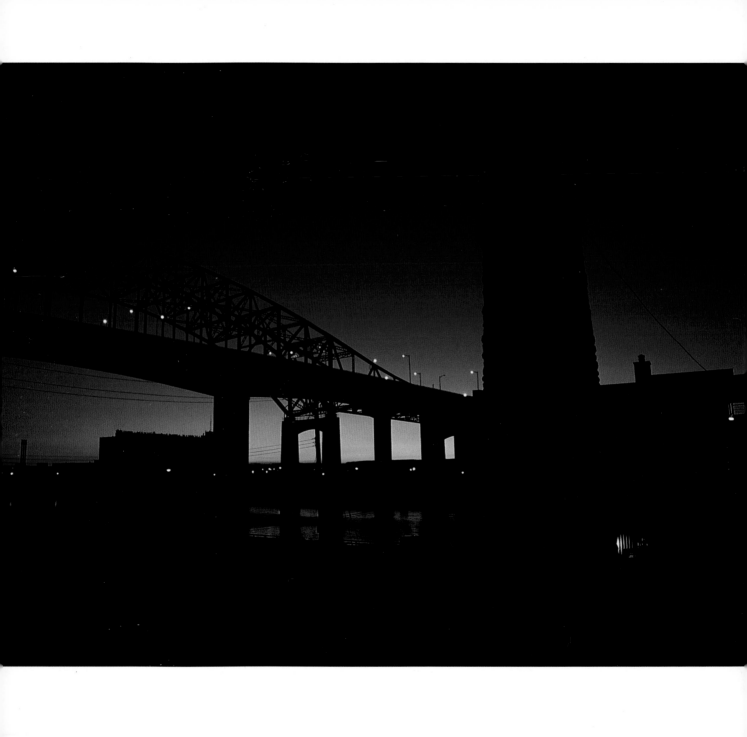

Burlington Bay

ONTARIO

During the early nineteenth century, as shipping increased on the St. Lawrence River, Burlington Bay was considered an excellent location for a new harbor because it was sheltered, provided good anchorage, and could be easily defended. However, its access was limited due to its narrow and shallow entrance. The government decided to build a canal to join Burlington Bay to Lake Ontario. The first public work undertaken with the financial backing of the provincial government, it was proposed as one of a series of waterways to provide uninterrupted navigation from Lake Erie to the Atlantic Ocean.

In 1823, at the urging of Hamilton merchant James Crooks, the House of Assembly authorized construction of the canal. A lighthouse was built at the mouth of the channel to guide ships into the canal entrance. Although work was not yet finished, the waterway was officially opened by the lieutenant-governor, Sir Peregrine Maitland, on July 1, 1826. The *General Brock* was the first schooner to pass through. Caught in a crosswind, it turned and ran aground in the canal.

Winter storms of 1829–30 destroyed the lighthouse and the piers, and left a huge sand bar blocking the canal. But the government started to rebuild, and the Burlington Bay Canal was completed in 1832, thereby insuring Hamilton's rapid growth as an industrial center at the head of Lake Ontario.

Also in 1832, two new mast lights were constructed to guide ships into the harbor entrance. The first recorded lighthouse keeper on the beach was a Mr. M. Homer, who earned five shillings a day. People soon realized that these lights were inadequate during severe storms, so in 1837 an octagonal wooden lighthouse was built on a stone foundation at the canal by John L. Williams, an American.

William Nicholson was appointed keeper in 1837. During that year, duties from vessel owners were collected to pay for construction and maintenance of the new lighthouse. The lighthouse burned 213 gallons (969 litres) of whale oil annually. It went through twelve dozen wicks for its Argand lamps, 20 pounds (9 kg) of soap and two chamois to clean the glass of the lantern, and 10 pounds (4.5 kg) of whiting for the exterior. The light was visible for 15 miles (24 km).

In 1856, sparks from the steamer *Ranger* caused a major fire that burned the pier and destroyed the second lighthouse. A new limestone lighthouse was built by John Brown of Thorold, who had just completed construction of the six Imperial Tower lighthouses on Lake Huron and Georgian Bay. Its base walls were 7 feet (2.1 m) thick and it had a spiral staircase and a copper cap.

This was the first Canadian lighthouse to burn coal oil instead of whale oil. Much controversy arose over this, but coal oil eventually became popular, and by the 1860s many Canadian lighthouses were using it.

Due to land development, industrialization, confusion of lights and shipping accidents, the Burlington Bay lighthouse was decommissioned in 1961 and the main light was placed atop the new lift bridge. Today the lighthouse stands below the abandoned Burlington Bridge.

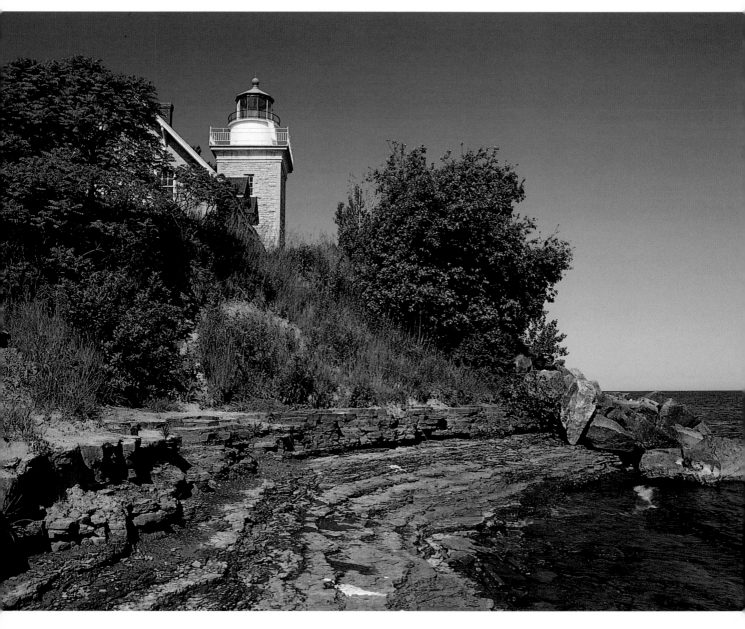

Thirty Mile Point

NEW YORK

This lighthouse is 30 miles (48 km) east of the mouth of the Niagara River, on Lake Ontario, near the mouth of the Golden Hills Creek. It was built in 1875 to warn vessels of a treacherous sand bar and dangerous shoals. Several vessels had been wrecked in the area. The most notable of these was the HMS *Ontario*. It was sailing from Niagara, New York, to Oswego with British troops, supplies, military gear and an army payroll estimated at about $15,000 in gold and silver. The ship left Niagara in a blinding snowstorm on the night of October 31, 1780, and was never seen again.

The Thirty Mile Point lighthouse is made of hand-hewn limestone blocks that were brought by schooner from Chaumont Bay, near the source of the St. Lawrence River. The square 70-foot (21 m) tower is attached to the keeper's dwelling.

The lighthouse's third-order Fresnel lens was imported from France and cost $15,000. It magnified the beam from a kerosene-mantle brass lamp to 600,000 candlepower and had a visibility of 16 miles (26 km). Originally it was turned by clockworks that had to be rewound by hand every few hours. The light's distinctive flash sequence — once every seven seconds — helped ships locate their exact position along the shoreline.

The attached lightkeeper's house is also made of gray limestone blocks. Dormers rise out of the slate roof and interrupt the eaves, under which are decorative braces. A yellow-brick addition was constructed and an assistant lightkeeper was hired. Each keeper had a twenty-four-hour shift. The light was checked every three hours and a weather log recorded every four hours. The lantern room was scrubbed and all the brass polished daily.

In 1935 the U.S. Coast Guard assumed ownership of the lighthouse. Inspections became a regular part of the lightkeeper's life. In addition to maintaining and cleaning the light, he now had to maintain the grounds, record the lake traffic, and report any distress situations. Food stocks were increased in winter so the lightkeepers' families could survive if a storm blocked the Seven Tenths Mile Road.

Over the years, the sand bar eroded, and eventually the lighthouse was no longer needed. It was decommissioned on December 17, 1958, and replaced by an automatic light on a steel tower, which is maintained by the Coast Guard.

In 1994, $95,000 was spent to restore the lighthouse to its original appearance. This cost included a new slate roof, rebuilt chimneys and new lead-coated copper gutters. The grounds have retained all adjoining buildings, which include a horse stable (now a garage), two oil houses, a pump house, a privy, a workshop, a cement dock, and a 1935 fog-signal building. The keeper's house displays the early furnishings of the lightkeepers. Visitors can climb the circular steel tower staircase to the decagonal lantern for a panoramic view of the grounds and Lake Ontario. On a clear day you can see the Canadian shoreline between Oshawa and Port Hope.

The Thirty Mile Point lighthouse was honored in 1995 by the U.S. Postal Service with a commemorative stamp.

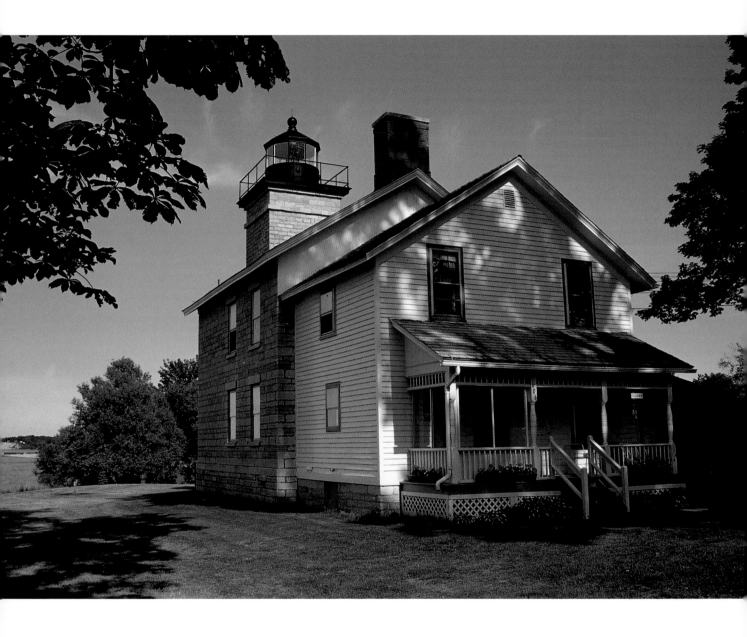

Sodus Bay

NEW YORK

In 1824 Congress appropriated $4,500 to construct a lighthouse at Sodus Bay. The land for the lighthouse was purchased from the Pultney Estate for $68.75. The lighthouse was built in 1825.

It is no longer there today, but according to the building specifications it was a 40-foot-tall (12 m), round, split-stone tower. Its walls were 3 feet 6 inches (1 m) thick at the bottom and tapered to 2 feet (0.6 m) at the top. The tower had three windows with twelve lights each. At the top of the tower was a stone deck 12 feet (3.7 m) in diameter, 4 inches (29 cm) thick. The tower had an octagonal iron lantern with a sliding ventilator in the copper sashes of each side. The lantern was capped with a copper dome. In one of the sides was a small iron door leading out to an iron balustrade with two railings around the lantern. A small, one-story split-stone keeper's dwelling was also built — a two-room house with a chimney in the middle and a fireplace on each side. Each room had three windows. The first lightkeeper here was Ishmael D. Hill, a veteran of the War of 1812.

Piers were constructed at the entrance to Sodus Bay in 1834. Over the next two years Congress approved funds for beacon lights on the piers. The stone beacon at Sodus Bay was built on the west pier as a guide for entering the harbor. In 1870 a new, permanent beacon was installed on the pier.

By 1869 the tower and keeper's house had deteriorated and Congress appropriated $14,000 to replace them. Limestone for the new 45-foot (14 m) square tower and attached two-and-a-half-story dwelling was quarried from Kingston, Ontario. The stone from the original lighthouse was used to make a jetty to protect the site from erosion. The tower was fitted with a fourth-order Fresnel lens. The new buildings were completed in 1871.

In 1892 the lighthouse and grounds underwent some improvements. The storm house that sheltered the rear entrance was enlarged to be used as a summer kitchen. The property fence was rebuilt and a circular, brick-lined oilhouse was built 128 feet (39 m) from the lighthouse.

In 1901, four concrete piers were built to replace the wooden ones. The pier beacons were raised 15 feet (4.6 m), giving them a new focal plane of 47 feet 6 inches (14.61 m) and a visibility of 14 miles (22.4 km). Because of improvements to the pier beacon, the Lighthouse Board deemed the lighthouse on the bluff unnecessary. On January 7, 1901, they closed the lighthouse and moved the oilhouse closer to the pierhead beacon.

The keeper's house was used from 1901 to 1984 to house personnel who maintained the pier lights. In 1984 the U.S. Coast Guard turned the lighthouse and its outbuildings over to the Town of Sodus Point.

Today the Sodus Bay lighthouse is on both the State and National Historic Registers and is leased and maintained by the Sodus Bay Historical Society. The lighthouse contains a museum, lighthouse artwork and photography, and a gift shop. From the tower you can see the Chimney Bluffs to the east.

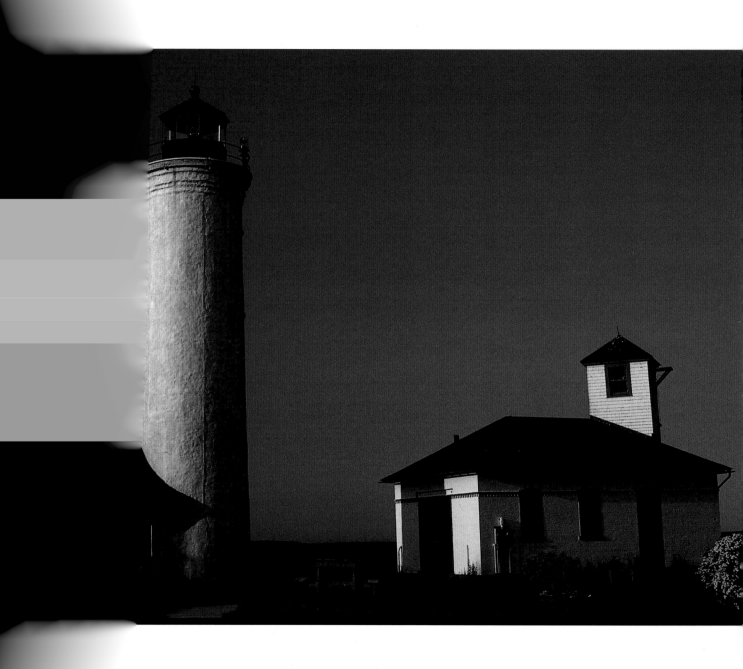

Tibbetts Point

NEW YORK

A lighthouse was constructed at Tibbetts Point in 1837 to mark the entrance into the St. Lawrence River. The first tower burned whale oil and was in service until it was replaced in 1854. The new tower, 61 feet (18.6 m) high, is a solid white cylindrical tower with a stucco-like finish. It was first equipped with a 50-candlepower oil lamp and a fourth-order Fresnel lens. Later the oil lamp was changed to a 500-watt electric lightbulb that generated 15,000-candlepower light. The fourth-order lens remained.

In 1896 a steam-operated fog whistle was added. The whistle was replaced in 1927 with a diesel-powered air diaphone, which emitted automatically timed blasts. Today a radio beacon guides ships into the river.

The Tibbetts Point lighthouse remained a Coast Guard station until 1981. In 1988, the Tibbetts Point Lighthouse Society was formed with the purpose of restoring the lighthouse and the grounds as an educational and historical entity. The buildings on the site include the tower (which has a small room added at the base), a two-story wooden lightkeeper's dwelling, a fog-signal building and an oil house. The tower, a State Historic Site, is still an active light maintained by the Coast Guard, while the keeper's dwelling now serves as an American youth hostel.

Residents and tourists can walk, bike or drive the 2 1/2-mile (4 km) lighthouse road from Cape Vincent to view the ice piled up on the shore during spring break-up, watch boats and ships passing by, and enjoy beautiful lake sunsets. Many important historical landmarks are also visible from the lighthouse: Wolfe Island, named after the English General Wolfe; Grenadier Island, scene of the ill-fated Wilkinson Expedition and the burning of the *Wisconson*; and Carleton Island, which served as a rendezvous for the Mohawks and as a sentinel point during the Revolutionary War.

Dunkirk

This lighthouse, also known as the Point Gratiot lighthouse, was first commissioned in 1826 and was built the following year on a bluff on Point Gratiot, where it overlooks the harbor. Its light works along with a pier-head beacon to guide vessels safely into Dunkirk Harbor on the south shore of Lake Erie. In 1857 it was refitted with a $10,000, imported, third-order Fresnel lens, which had a 17-mile (27 km) visibility range and was reported to be the most prominent light on Lake Erie's south shore. The light was fueled first by whale oil, then acetylene gas, and finally kerosene.

In 1874 the tower was reported to be in poor condition. In 1875, a new tower and keeper's house were built. This tower, built with blocks of local siltstone, is 61 feet 3 inches (18.7 m) tall from its base to its ventilator ball on the top. Its focal plane is 82 feet (25 m) above lake level. Inside, an ornate spiral cast-iron staircase leads up to the decagonal lantern. Two of the ten sides of the lantern are not glazed, so that the light may be seen from the water surrounding the point but does not shine on land. The third-order Fresnel lens was transferred from the old tower to the new one. Today the light is automated.

Ten solid-brass lion-head drain spouts around the lantern's roof once helped to drain off the condensation that formed on the glass and dome of the lantern. Cupboards with curved wooden doors were built into the corners of the lighthouse to make use of the space between the original curved inside wall and the square walls that were built around it. A covered passage connects the tower to the keeper's house, a large two-story redbrick house built in a variation of the Gothic Revival style that flourished after the Civil War. Interesting features include the delicate ornamental cross-bracing under the eaves, dormers that rise out of the brick walls and through the eaves on both sides of the house, and wooden finials that rise from the house and dormer gables. The small porch on the south side was added some time after 1892. The windows and doors have flat stone lintels and sills.

The original fog signal was a cannon. During heavy fog the army would send a sergeant and two operators to blast the cannon once every five minutes. This proved to be a very expensive fog signal, and eventually electric bells were installed.

The well-maintained lighthouse is now part of the Dunkirk Historical Lighthouse and Veteran's Park Museum. The entrance to the park is marked by a unique bottle-shaped light, once one of the Buffalo Harbor bottle lights. The keeper's house is now a museum. Five rooms contain displays that commemorate the five service branches of the U.S. Armed Forces (Coast Guard, Marine Corps, Navy, Army and Air Force). Also on display on the grounds are a 40-foot (12 m) lighthouse-buoy tender, a rescue boat, assorted anchors, a lightkeeper's rescue boat, a 1923 U.S. Lighthouse Service bell, a torpedo, and other lighthouse lenses.

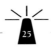

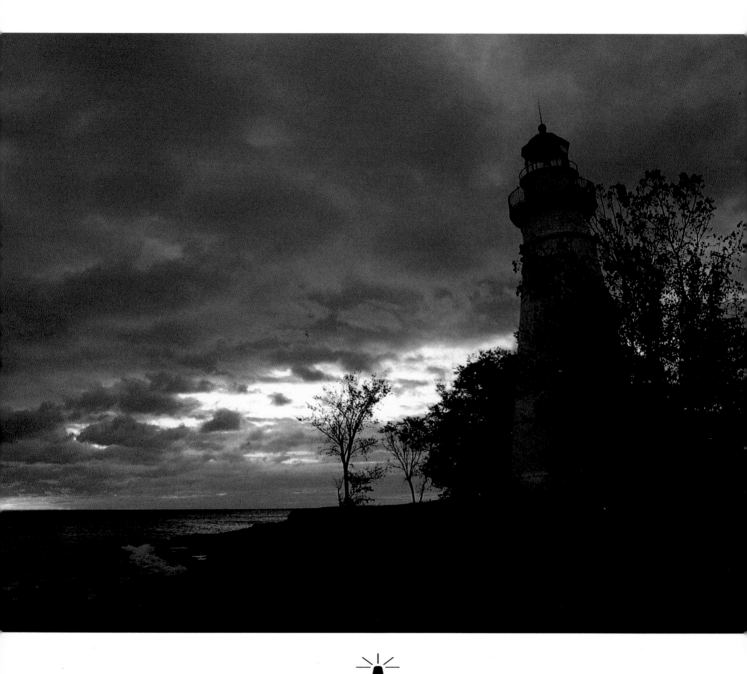

Marblehead

OHIO

As storms come up quickly on Lake Erie, and Marblehead Peninsula is surrounded by islands offshore, it is one of the roughest areas on the lake in stormy weather. Marblehead lighthouse is the oldest lighthouse in Ohio. The limestone tower was built in 1821 with stones quarried from Marblehead, Ohio. Its original lantern had thirteen lamps and reflectors.

The first keeper's house was built of fieldstone in 1823, but it was 3 miles (4.8 km) from the light tower. This building is now owned by the Ottawa County Historical Society. The first keeper was Benajah Wolcott, who was succeeded after ten years by his wife, Rachel. In 1896, George McGee was keeper. When he died, his wife also took over as lightkeeper.

A new, two-story Victorian-style keeper's residence was built in 1902, adjacent to the lighthouse. In 1969, because of vandalism, the U.S. Coast Guard ordered that the house be burned. Concerned citizens protested and saved the house. It is now owned and protected by the Ohio Department of Natural Resources, which uses it as a private residence.

A life-saving station was built in the area in 1876 because of numerous shipwrecks. Between 1879 and 1903 the tower was extended up another 15 feet (4.6 m) to its present 65 feet (20 m). It is topped by a decagonal lantern. In 1903, a new, third-order Fresnel lens was added. Its visibility range was 16 miles (26 km). The Fresnel lens was later removed and is now on display nearby at the Marblehead Coast Guard Station. An electric light was installed here in 1923. By 1946 the lighthouse was fully automated and unmanned. Today it is lit by a solitary green plastic beacon and is the oldest active light on the Great Lakes.

The area is rich with history. South of Marblehead lighthouse is Johnson's Island, where there was once a prisoner-of-war camp for thousands of Confederate officers. Three miles (4.8 km) away is Kelley's Island, notable for its glacial rock formations, Native petroglyphs, and inscriptions cut into the rocks.

In honor of Marblehead lighthouse and its history, the U.S. Postal Service issued a commemorative stamp of the lighthouse in 1995. It was one of five lighthouses so honored.

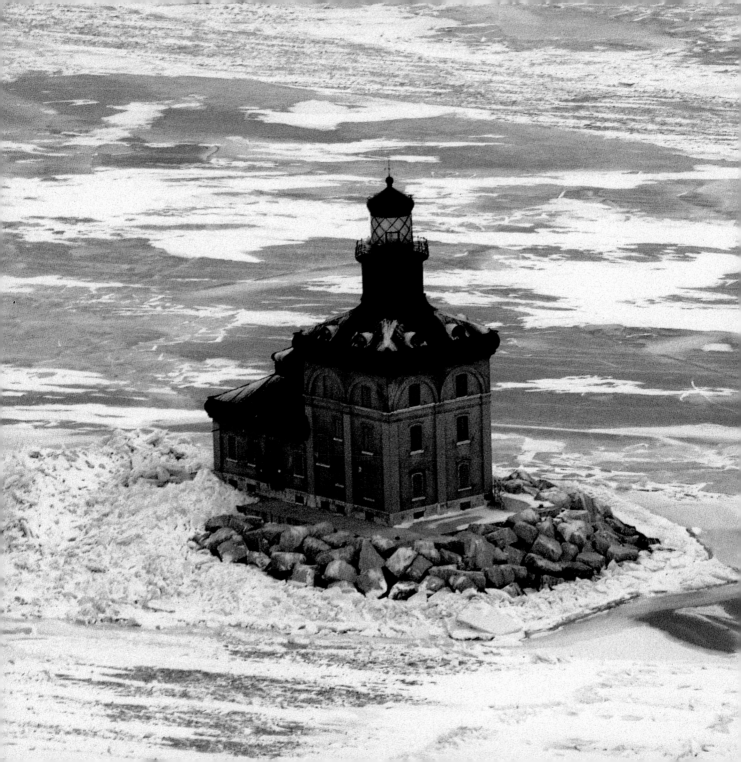

Toledo Harbor

Completed in April, 1904, the lighthouse stands 12 miles (19.3 km) out in Lake Erie, in about 21 feet (6.4 m) of water, and marks the entrance to Toledo Harbor. Its first lightkeeper was Dell Hayden, and his assistant keeper was Edward Reicherd. When it was built it was considered the most modern lighthouse and fog-signal station anywhere in the world. Its illuminating apparatus cost $5,000 and was a feature exhibit at a Pan-American exposition.

Construction started in 1901 with the building of the huge crib. The 12-by-13-inch (30 by 33 cm) hemlock timbers were faced with 4-inch (10 cm) oak planking and bolted together with iron screw bolts. In May the crib was launched and towed to the site. It was topped with the lighthouse foundation, constructed of huge solid-concrete blocks built up to a height of about 12 feet (3.6 m) above lake level. The lighthouse and fog-signal station were built on top of this.

The lightkeeper's house and tower were built as one unit, complete with a basement, three stories, an attic and a watchroom. The floors contain an office, the engine and power room, and kitchens, sitting rooms, bedrooms and bathrooms for the two lightkeepers and their families. Above all this rises the tower with its watchroom and lantern. The wind gauge is 90 feet (27.5 m) above lake level.

The lighthouse has uniquely styled Moorish roofs. Inside the keeper's dwellings, the walls were finished in quarter oak and the floors in polished maple. There were also polished brass and bronze plumbing fixtures. With its furnace and hot and cold running water, it was considered the best lighthouse of its time.

The fog-signal building, attached to the keeper's house, was a one-story addition on the northeast side. The fog signal was a series of three-second blasts separated by seventeen seconds of silence. This was the first signal on the Great Lakes to be operated by compressed air. The compressors were powered by a Hornsby-Akroyd oil engine.

The circular lantern is surrounded by a circular parapet enclosed by a metal railing. The quarter-inch (0.6 cm) curved-glass panes are set into diamond sashes. Housed inside is a third-order Fresnel lens that revolves on ball bearings, making one complete revolution every eighty seconds and giving three flashes every revolution, one red and two white. Its focal plane was 72 feet (22 m) above the lake level and its visibility was 16 miles (26 km) in all directions. The lens revolved by a clockwork powered by weights. The original oil lamp was replaced in 1953 with a 500-watt bulb, which the lens magnified to 190,000 candlepower. It now uses a 1,000-watt bulb.

In 1966 the U.S. Coast Guard automated the lights and the fog signal. The lighthouse also sends out a radio beacon that boats can use to fix their positions.

In 1986 the Coast Guard put a mannequin dressed in a lightkeeper's uniform in a second-story window to give the place a lived-in look and prevent vandalism. Boaters soon started a rumor that this was a ghost, and it quickly became known as the Phantom of the Light.

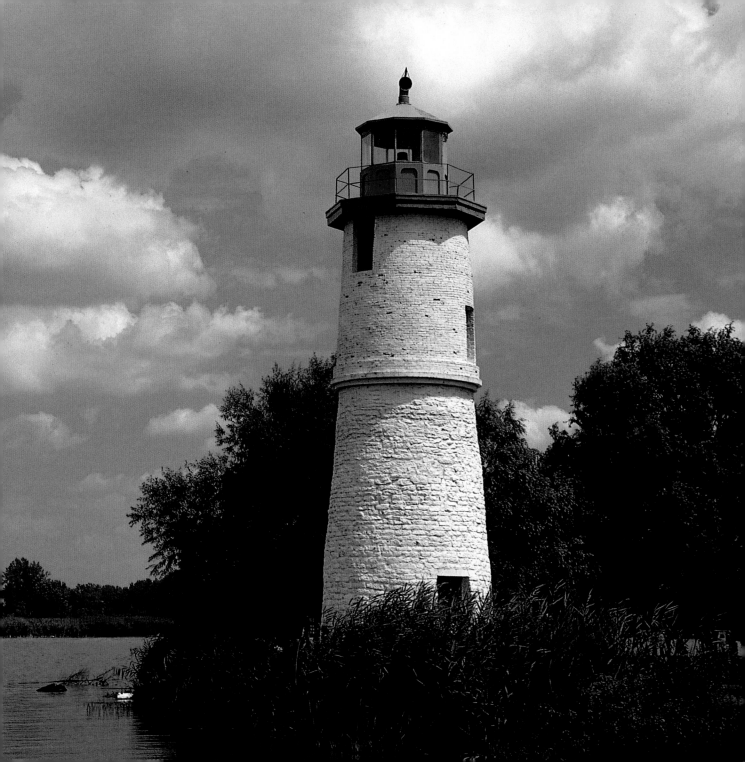

Old Thames River

ONTARIO

One of Canada's oldest lighthouses is located at the mouth of the Thames River, where it empties into Lake St. Clair. The date of origin of the first Thames River lighthouse is unknown. Around the time of the War of 1812, the Cartier family (thought to be descendants of Jacques Cartier) settled in the area by the mouth of the Thames River. The family fished on Lake St. Clair. To guide them home after dark, they would hang a lantern to a post on the shore.

At first a wooden-frame lighthouse was built in the marsh. That building was destroyed by fire and the lower portion of the existing stone lighthouse was built in about 1818. The walls of the existing lighthouse were 4 feet (1.22 m) thick at the base and tapered to 2 feet (0.61 m) thick. The limestone for the walls was quarried in Amherstburg. Inside the lighthouse, a circular, limestone staircase spiraled to the lantern at the top. There, a platform surrounded the glassed-in light. An addition was constructed around 1867, as the tower was considered too short to guide the boats in. The original height is marked by a protruding ring about two-thirds of the way up the side of the structure. The addition brought the lighthouse to a height of 55 feet (17 m).

The first light was a huge brass affair that revolved when lit and could be seen for about 12 miles (19 km) offshore. Kerosene lamps were used until an electric light was installed in 1963.

In the early days, the lighthouse guided large sailing craft and steamships from the lake to the river. As land development altered the surrounding area, the lighthouse's main function became guiding pleasure and fishing boats. Three generations of the Cartier family manned the light from its inception until 1950. At that time, C.W. Riberdy, an experienced river man, took over. Armand Jacob was the last lightkeeper.

In 1966, the Department of Transport deemed the lighthouse unsafe, as it leaned slightly to the east and had cracks in its walls. A modern tubular-steel tower, capped with an automatic light was built. The old lighting apparatus was dismantled and, unfortunately, was lost.

The Lower Thames Valley Conservation Authority acquired the historic site from the federal government to create a conservation and recreation area. In 1973, the Lower Thames Valley Conservation Authority restored the lighthouse by taking down the structure stone by stone, fixing the foundation, and then rebuilding. Today, the refurbished lighthouse remains as a tribute to the early history of the area.

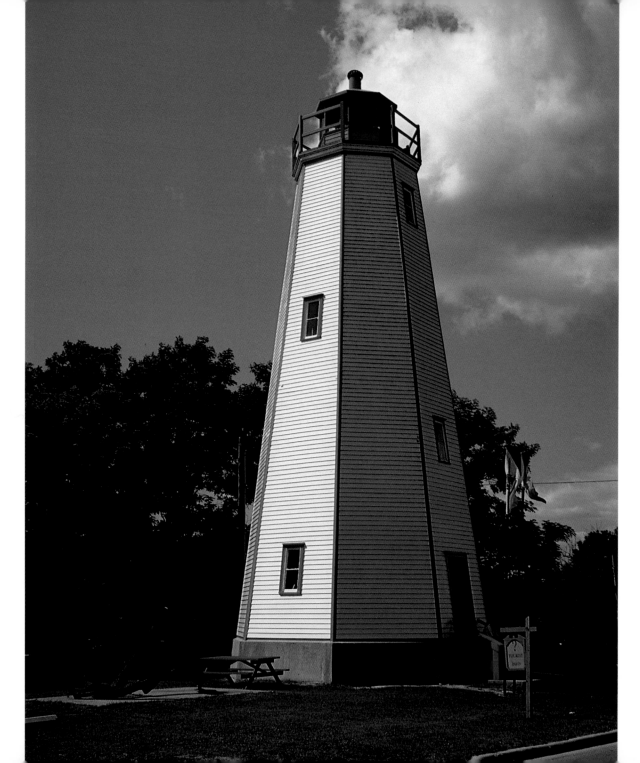

Port Burwell

ONTARIO

The Port Burwell lighthouse was constructed in 1840 with financing from the British government. The site was chosen because it formed a natural harbor where Big Otter Creek drained into Lake Erie. Much of the shoreline between Port Burwell and Long Point to the east is clay cliff with no refuge for vessels in a storm. Since this was the only light on Lake Erie's north shore in 1840, it was a very important beacon to guide vessels to safety during Lake Erie's violent storms and to warn crafts of their location so they could maneuver their way around the point.

The lighthouse is not only the oldest lighthouse on the north shore, but it is also one of the oldest in Canada. It remained in service for 112 years (1840–1952) without the aid of electricity. It then operated with an electric light from 1953 until 1963, when it was removed from service.

This octagonal wooden structure was framed with large, upright, pine timbers that tapered at the top. Lapstrake wooden siding was then attached to the frame. The lighthouse stands 65 feet (20 m) high on the banks of the Big Otter River, 130 feet (40 m) above Lake Erie.

The original oil lamp required 71 gallons (323 litres) of oil and seventy-two wicks for one year of service, providing 2,929 hours of burning time. Even after the light was electrified, the original Fresnel lens remained in the lantern to magnify the light beam. This lens is still in the tower today.

The first lightkeeper here was probably Thomas Bellairs. However, the Sutherland family were the official lightkeepers for well over a century (1852–1963). Alexander Sutherland, the first Sutherland lightkeeper, reported that over fifty vessels came to grief in the Port Burwell area during his tenure (1852–1873).

Some excellent descriptions of life as a lightkeeper were left by Alexander's son John. As well as maintaining the main light, John had to light the lamps at the end of the short piers. This was quite dangerous in stormy weather. John was frequently washed off the wooden pier by storm waves smashing over the breakwater. He was a strong swimmer and was always was able to swim back, but he sustained many injuries over the years. In 1935 John was awarded the King George V Jubilee Medal. After John retired in 1939, a special ceremony was held at Iroquois Beach to further honor his long service and courage with the King George VI Imperial Service Medal.

When the light was removed from service, the Village of Port Burwell asked to be given title to the historic structure. In April 1965 the request was granted. In 1986 a Mennonite craftsman, Leroy Eicher, was hired to restructure the foundation and replace the main beams, because he and his sons still used the same hand tools used to build the original tower. The pine beams were replaced with Douglas fir, for greater durability. The original spiral staircase was replaced with a zigzag staircase for the safety of tourists. The refurbishing was completed in 1987.

Today visitors can climb to the top for a spectacular view of the harbor, lake and village. Beside the lighthouse are large anchors from the schooner *Nimrod*, which sank after colliding with another ship in the fog off Port Bruce. Across the road from the lighthouse, a marine museum houses an excellent collection of lighthouse lenses.

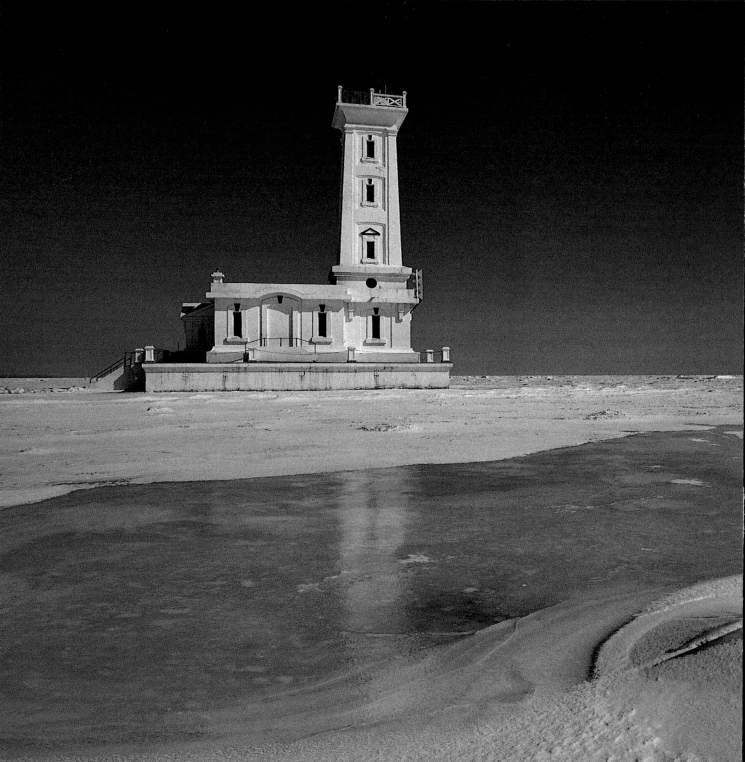

Point Abino

ONTARIO

Point Abino, a popular area for summer residents, juts two miles into Lake Erie and is located about halfway between Fort Erie and Port Colborne on the north shore of the lake. The point is named after a French Jesuit, Reverend Claude Aveneau, who lived there about 1690. (Mispronounced, the name was changed to Abeneau and later Abino.)

In 1917 the Canadian government decided to replace the navigational beacons in the lake with a lighthouse on the point to warn ships of the dangerous waters. The Point Abino lighthouse was built on a rock shelf in the lake. Because it was built out in the water, it had to house both the light and the fog signal. The lighthouse stands 98 feet (30 m) high and has five levels, each reached by ladder stairs. This lighthouse is more ornate than other lighthouses built at the time. The keeper's house, built three years later, is equally grand. It was a two-story Tudor-style house, built onshore.

The first lightkeeper was Pat Augustine, who started in 1918 and stayed for thirty-five years. For the first few years supplies had to be brought in by boat. The last lightkeeper was Lewis W. Anderson, who retired at the end of 1988 after almost thirty years. Mr. Anderson, a native of Cape Breton Island, says he did not set out to be a lightkeeper, but took up the profession after taking early retirement from the Canadian Army.

The light was originally fueled by kerosene. The lightkeeper had to climb to the top of the tower every six hours to rewind the chain and weight mechanism that turned the rotating lens. Later, the lens was rotated by a half-horsepower motor and an electric generator. In the late 1930s the lighthouse switched from generators to full hydroelectric power. A 500-watt mercury-vapor bulb supplied the powerful light, which was shone through a double set of Paris-made, cut-glass Fresnel lenses. The lens rotated approximately every twelve seconds and had a visibility of 20 miles (32 km).

In his early days, as well as operating the diesel engines that provided electrical power for the light, Mr. Anderson also had to operate the compressors, which ran the foghorn. The foghorn's distinctive signal was three blasts, each followed by forty-eight seconds of silence. Because the foghorn was housed within the lighthouse, the sound was almost unbearable. According to Mr. Anderson, "It would reverberate through the whole tower, and you'd just have to get out of there." The foghorn was later replaced by an electrical horn that was barely audible on land, and was discontinued in 1995.

In 1972, Mr. Anderson and his assistant worked twelve-hour shifts, seven days a week, during the navigation season. Once electricity was introduced to the lighthouse in the early 1980s via an underground conduit, it became an eight-hour-a-day maintenance job. In 1987 the government decreed that only certain lighthouses would remain manned, because of the particularly harsh weather conditions at those locations. Point Abino was one of these. When Mr. Anderson retired, he was kept on as a caretaker–security guard and allowed to remain in the lightkeeper's residence.

The light was fully automated for the 1989 shipping season and the automated light transmitter was linked to the Canadian Coast Guard Headquarters in Prescott. The lighthouse is now controlled by Transport Canada and the Canadian Coast Guard, and its operations are monitored from Toronto.

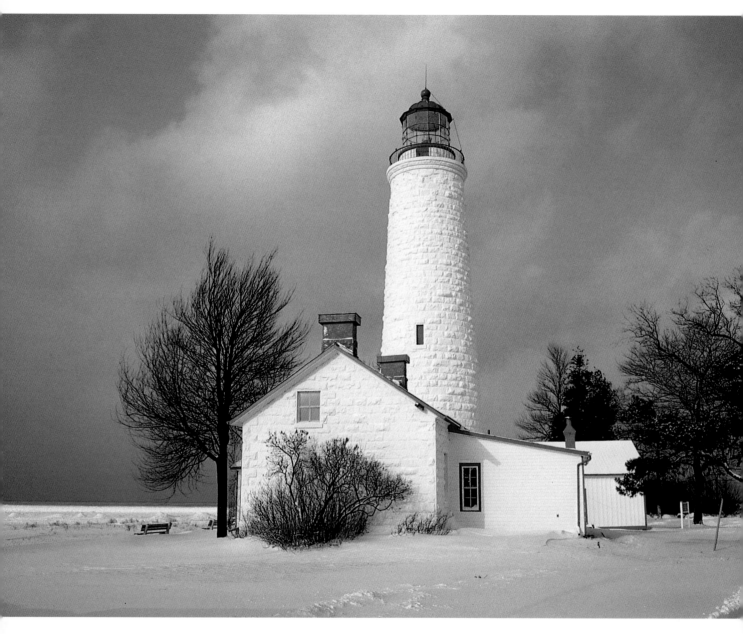

Point Clark

ONTARIO

In the 1830s, before there were any lighthouses on the Ontario side of Lake Huron, ship travel from Goderich to the area north of Point Clark was treacherous. At first, a lantern was hung in a pine tree to warn seamen of the rocky shoals that stretched for 2 miles (3.2 km) into the lake from Point Clark. Because of this, the point was originally known as Pine Point. It was later named Point Clark after families from Clark Township, east of Toronto, who settled on the height of land above the point.

Shipping and water travel on Lake Huron was on the increase, but Lake Huron was poorly lit. By 1848, the only lighthouse was at Goderich. So in 1855, the Department of Public Works hired John Brown, an experienced contractor, to build more lighthouses to light the east side of Lake Huron and Georgian Bay from Point Clark to Christian Island. Brown completed six of the eleven planned lighthouses. The final cost of the six lighthouses was $222,564, an astronomical amount for the 1850s. These six lighthouses, all built from the same plans, became known as the Imperial Towers.

The lower level of the Point Clark lighthouse was made of limestone, which was hewn either at the nearby quarry in Inverhuron or at Kingston. The walls of the lighthouse had to be extra strong to support the cast-iron base plate and lantern, which held the Argand lamp and second-order Fresnel lens. Because of this, the top walls were made of granite. The lighthouse stands 87 feet (26.5 m) high. Its revolving white beacon, which flashes every thirty seconds and is visible for 15 miles (24 km), was first lit on April 1, 1859. Nine flights of stairs (114 steps) lead up to the lantern. The original circular staircase has been replaced with a zigzag one.

The original lamps burned sperm whale oil. For each quart of oil burned, over one quart of water vapor was produced. All six Imperial Towers had collector troughs inside the lantern. These eliminated most of the condensation by draining the water out through lion-head spouts located around the outside of the lantern. During the winter season, however, this water vapor would condense on the windows of the lantern. The keeper would have to scrape the ice from the windows so that the light would not be obscured. All six of the Imperial Towers have rounded copper domes, pointed at the top, in the imperial style. Perhaps this is where they got their name.

The two-story limestone lightkeeper's residence is a separate building connected to the lighthouse by two trap doors and an underground tunnel. This enabled the lightkeeper to service the lamp in the severest of weather and to make a relatively quick trip to refill the oil and rewind the weights at 2 A.M. without having to go outside. In 1967, the Point Clark lighthouse became the first lighthouse in Ontario to be declared a National Historic Site. The refurbished buildings are now part of a national park, with picnic grounds, a boat launch and a gift shop and marine museum.

Although all six Imperial Towers are still functional, Point Clark lighthouse is one of only two that have been well preserved. There is hope that more interest in restoring the other four will come in future years.

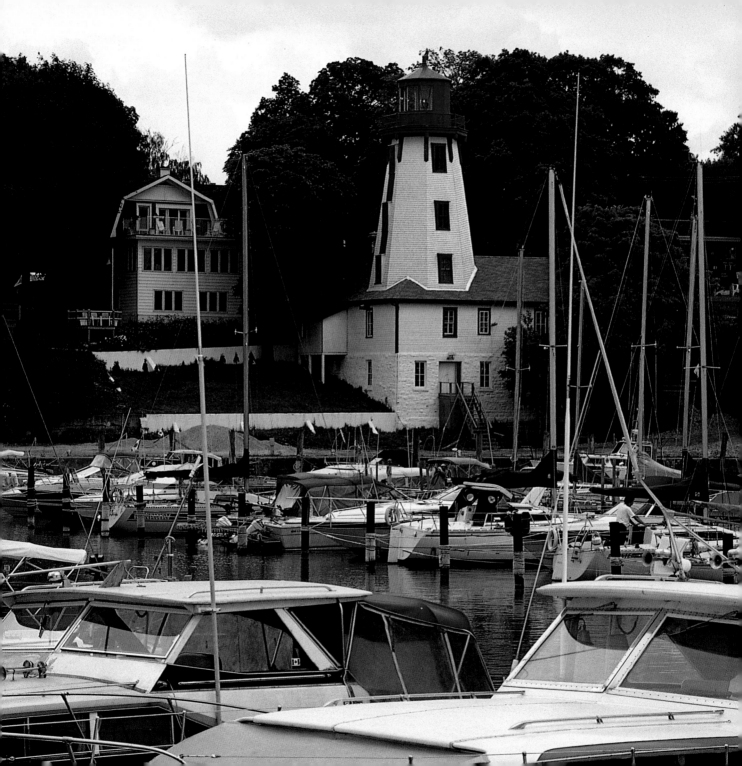

Kincardine

ONTARIO

In 1853 the first efforts were made to establish a harbor at Kincardine. At that time the primary industry of the town was fishing. In 1856 two parallel piers were built and ten years later the harbor basin was excavated. After the discovery of salt in the area in 1886, mining and exporting of salt became an important industry. With increased shipping, a light was needed. In 1874 a square tower was constructed at the end of the north pier.

Then in 1881, under the supervision of William Kay, a lighthouse was built into the hillside beside the mouth of the Penetangore River. William Kay became the first lightkeeper. This lighthouse site was originally home to the Walker and Henry Distillery. It has a white, wooden, two-story keeper's house, built on a stone foundation. The octagonal tower rises about 30 feet (9 m) above the housetop to an overall height of 80 feet (24.4 m). The twelve-sided lantern is only partially glazed and has metal panels on the east side. A red one-second flash, with a four-second eclipse, is sent from polished reflectors for a visibility of 21 miles (34 km) out over Lake Huron. Around the lantern is an octagonal gallery surrounded by an iron railing. The walkway is supported from underneath by eight decoratively carved wooden braces. The tower and dwelling are trimmed in red, and the tower's many windows provide natural lighting for its sixty-nine steps. The lighthouse also has a rear range light to guide vessels safely into the harbor.

The shoreline in front of Kincardine was quite exposed, and during storms, ships found it hard to manoeuver into the safety of the Kincardine Harbour. In 1902 a schooner trying to reach the safety of the harbor ran aground south of the piers. The townspeople, hearing her bell and the cries for help, sent out a lifeboat. However, a wave capsized the rescue boat after it had been loaded and five people drowned. Everyone else was saved by a second rescue boat.

In 1922 the kerosene oil light and steam foghorn were replaced with electric equipment. In 1970 the light was automated, employing a photoelectric cell. The light is still active today. The last family lived in the keeper's house until 1977; it was converted into a marine museum in 1980.

With the advent of the railroad to Kincardine, shipping dropped drastically. But the harbor is still very active today during the summer months, with yachts, sailing vessels, fishermen and tourists. It is easy to understand why Kincardine's lighthouse is one of the most photographed lighthouses in Bruce County.

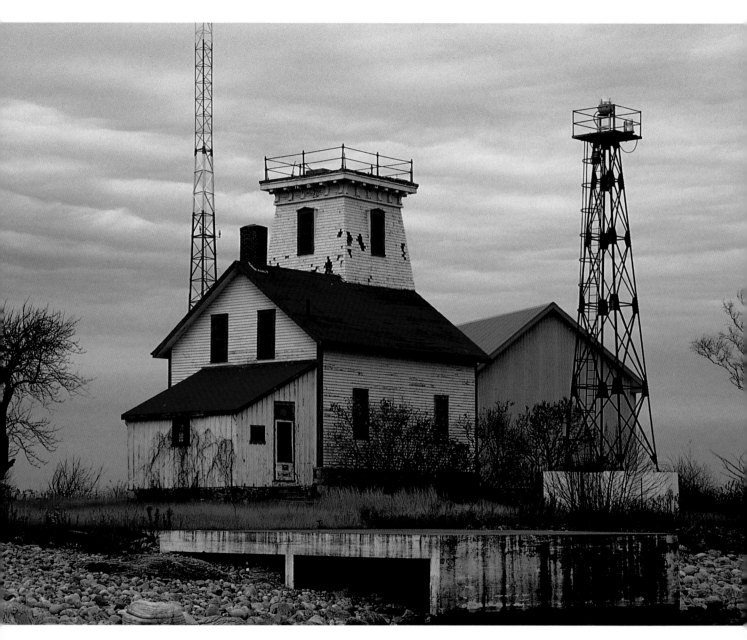

Hope Island

ONTARIO

The Hope Island lighthouse was constructed in 1884 on the northeast tip of the island at a cost of $1,864. The square wooden tower is 57 feet (17.4 m) from the ground to the vane on the lantern room. The light from this catoptric system (in which light is emitted vertically and reflected along a horizontal plane) was visible for 12 miles (19 km) in all directions.

The first lighthouse keeper, Charles Tizard, earned $450 per year. Tizard died suddenly in 1886, but his wife continued to operate the light long enough to witness a fierce storm that raised water levels to within 2 feet (0.6 m) of the lighthouse. In 1887, Allen Collins was appointed lightkeeper. On August 8, 1888, he assisted the crew of the American three-masted schooner *Imperial* when they arrived in a yawl at Hope Island after their ship sank.

In 1891, so that his children could go to school, Collins switched places with John Hoar, the keeper at Christian Island. Bickering soon resulted between the two keepers. Hoar complained that Collins left him a partially paid-for sailboat. Collins claimed that he had paid for a stove but that Hoar took it. The superintendent of lighthouses, Mr. Harty, was sent to investigate the problem in September 1892. After hearing both sides, Harty sided with Collins. Hoar had also built a wooden stable and shed with his own money at Christian Island lighthouse, and he asked to take it with him, but the superintendent denied his request. Hoar was livid. He next complained to the Department of Marine Services. His actions led to the appointment of Thomas Marchildon as lightkeeper at Hope Island for 1894. But Hoar, feeling cheated out of his job, refused to leave. When Marchildon arrived at Hope Island, he was discouraged from entering the lighthouse by a shotgun-toting Hoar. Marchildon was forced to camp on the island until the ice froze and reinforcements could be sent. Eventually the dispute was resolved and Marchildon was able to take over the post.

The Hope Island lighthouse has had its lantern removed, and the island is now served by a functioning light on top of a steel tower.

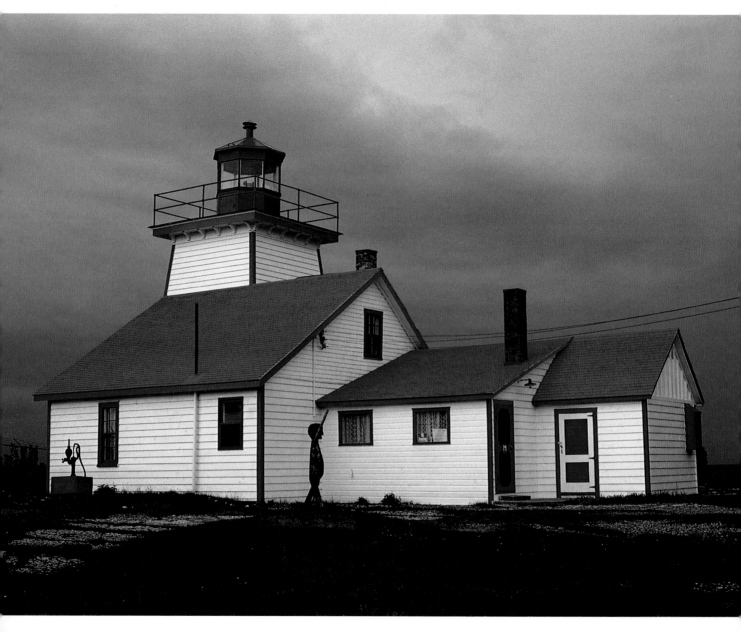

Mississagi

ONTARIO

Several sources list this lighthouse as being in Meldrum Bay, but it is actually over 6 miles (10 km) away, across the peninsula from Meldrum Bay on the Mississagi Straits. It was located here to protect and guide ships through the perilous, rocky passage of the straits that separate Manitoulin Island and Cockburn Island.

There have been many shipwrecks in the area. A magnetic reef off the east side of Cockburn Island threw off ships' magnetic compasses and sailors found themselves trapped on the dangerous shoal.

Over three hundred years ago a ship commanded by a Captain LaSalle, the *Griffin*, went missing in Lake Huron. No one knows exactly what happened. One theory is that it became lost in a storm at the Mackinac Straits and that the strong currents pulled it down to the Mississagi Straits, where it was wrecked on the magnetic reef. The wreck was washed ashore just north of the lighthouse. A large human skull was found in an underwater cave just north of the lighthouse. Some believe it to be the skull of Captain LaSalle, who was a large man.

The Mississagi is one of eleven lighthouses built on Manitoulin Island, the world's largest freshwater island. It dates to 1873 and today is the oldest standing lighthouse on the island. The lighthouse is 40 feet (12 m) high. The lightkeeper's one-and-a-half-story house is built onto the tower, so that the tower is actually a room in the house.

In 1881 a compressed-air fog signal was installed at the site to serve as a further warning of the dangerous coastline. In 1905, this fog system was replaced by a diaphone-type alarm. Today there is no fog alarm. The light was originally a coal-oil-fired wick lamp that required daily cleaning and filling. The original Fresnel lens is still there. Hydro was installed at the lighthouse in 1970, but in the same year a new automatic light was installed on a skeletal tower in front of the old lighthouse.

The first lightkeeper here was John Miller, who served from 1873 to 1887. A Mr. and Mrs. W. A. Grant ran the lighthouse from 1913 to 1946. During their stay, the ship *Burlington* burned at the dock in 1915. (The wreck is now a favorite haunt for divers.) Mr. and Mrs. D.N. (Joe) Sullivan served from 1946 to 1970. Joe opened the road to the lighthouse for car travel.

Today the Canadian Coast Guard owns and maintains the new light. The lighthouse is now part of a museum, furnished as it was by the keeper and his family a hundred years ago. The Manitoulin Tourist Association leases the Mississagi Lighthouse and Heritage Park from the LaFarge Construction Company. Since the site and road are privately owned, the lighthouse is only open to the public from the long weekend in May until the long weekend in September.

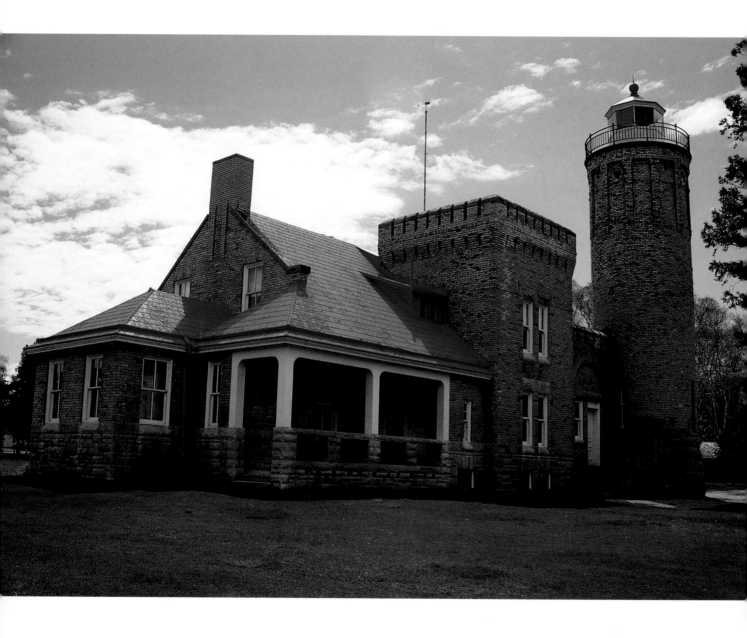

Old Mackinac Point

MICHIGAN

This lighthouse is at the turning point for ships making the difficult passage through the Straits of Mackinac, one of the busiest crossroads of the Great Lakes. McGulpin's Point lighthouse, 2 miles (3.2 km) to the west, was established in 1856, but it was not visible from all directions. In 1889 Congress appropriated funds for the construction of a steam-powered fog signal at Old Mackinac Point. It went into operation on November 5, 1890. Construction of the light tower and attached lightkeeper's dwelling soon began as well. Heavy iron and brass castings were used throughout the structure. The light was first displayed on October 25, 1892, and with its fourth-order Fresnel lens, was visible to ships 16 miles (26 km) away.

The Old Mackinac Point lighthouse resembles a medieval castle. It now sits in the center of a public picnic area beside the Straits of Mackinac, close to the Mackinac Bridge. The yellow-brick lightkeeper's house is built in a cross shape. On the northwest corner, a circular brick tower rises three stories from a tapered stone-block foundation. The five narrow windows, two at the bottom and three ascending the tower, are reminiscent of the arrow slits in a castle. The top of the tower has an outcropping of brickwork that runs around the top and down the sides in long fingerlike protrusions to frame four porthole-style windows that face north, east, south and west. The tower, topped by a red dome, is built into what looks like a square tower with a crenellated top but is actually part of the main house. The house, which has been added to at some point, has a red roof and three large brick chimneys.

As well as guiding ships through the difficult passage of the Straits of Mackinac, the lighthouse has also watched over a constant stream of ferries shuttling cars to the Upper Peninsula and Mackinac Island. In 1957 a bridge was built over the straits, connecting the two parts of Michigan. Its lights made the lighthouse unnecessary, so in 1958 the Old Mackinac Point lighthouse was decommissioned. The lighthouse is now a maritime museum. Its unique architectural style makes it a special spot to visit, especially at sunset.

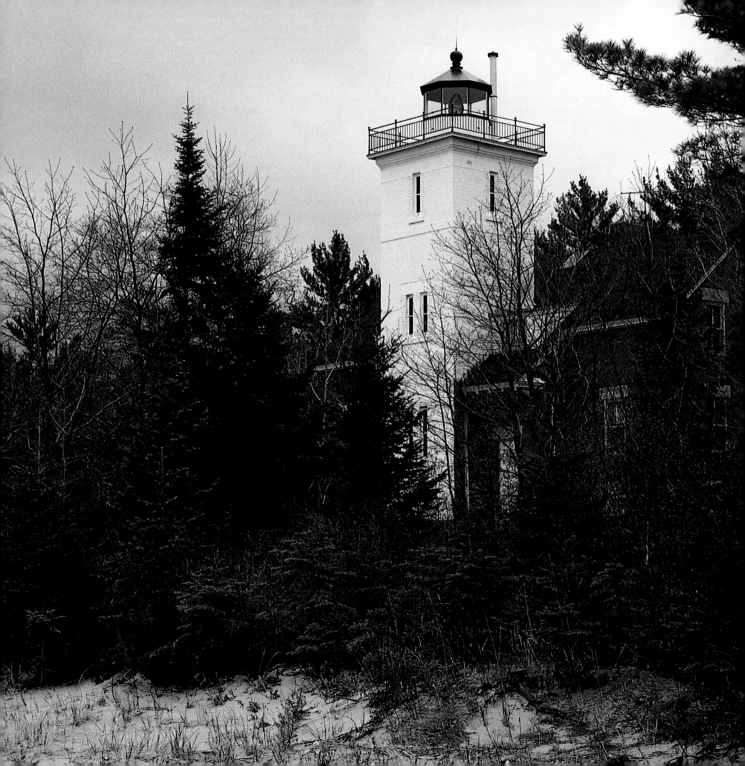

Forty Mile Point

MICHIGAN

This rectangular tower, built in 1896, is three stories high and painted white on three sides. The fourth side is built into the two-story house. The tower, which faces the lake, has twin windows on the first two levels and a single window on the third. There are fifty-six solid wrought-iron steps to the top.

A new light was installed in April 1897. The tower's original lens was powered by weights behind the wall that had to be set every four hours. The light has since been automated.

The lightkeeper's house here is markedly different from most, as it is a duplex. One half was for the lightkeeper and the other half for his assistant. The two halves are identical but reversed. At the back are two sets of hurricane doors and two entrances. At the front there are two sets of dormer windows, one set on each side of the tower. Inside, there is a door in each half of the house leading to the tower. Out back stand two brick outhouses. One of these still has the original asbestos shingles, set on the diagonal.

Karen Kamyszek has lived in one half of the house for eleven years. She and her husband, Bernie, maintain the park grounds in lieu of rent. According to her, there are four layers of brick in the walls with dead air space in between. The house has a high-ceilinged basement and a walk-up attic with skylights over the two attic staircases to light the stairs. There is a chimney for the tower's woodstove.

The second half of the house is presently being renovated to restore the interior to its original condition for use as a nautical museum. Also on the property, down on the beach, are the remains of the wreck of the *Joseph S. Faye* and the barge it was towing.

This lighthouse is now located in Lighthouse State Park and the U.S. Coast Guard maintains the light and the tower.

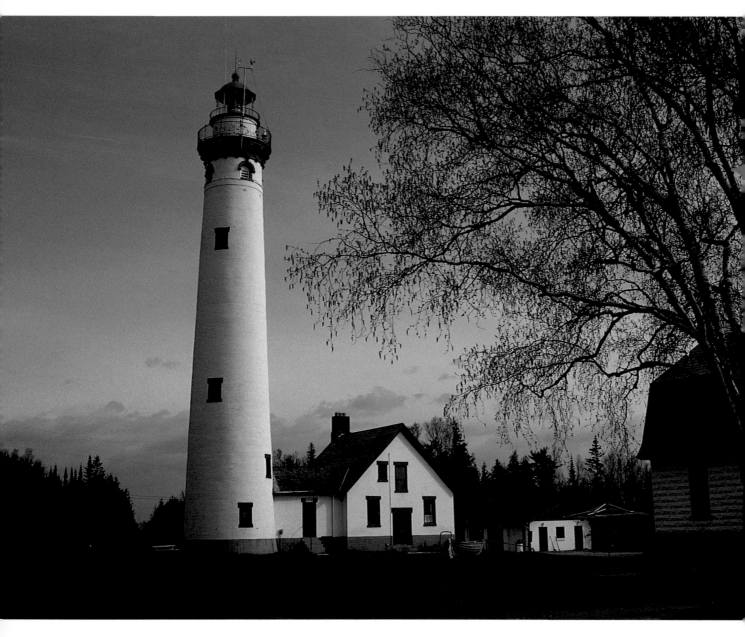

New Presque Isle

MICHIGAN

Five American lighthouses, known as the Tall Lighthouses of the Great Lakes, are distinguished by their height and their common architectural style. They are Wind Point, Wisconsin; Presque Isle, Michigan; South Manitou Island, Michigan; Big Sable Point, Michigan; and Grosse Point, Illinois. All but the last are over 100 feet (30.5 m) tall.

The New Presque Isle lighthouse was built in 1870 to replace the Old Presque Isle lighthouse. The original lighthouse, built closer inland, guided steamers into its harbor for refueling. But with the advent of coal-burning vessels, the harbor became less important to ships. It became more essential to have a light that could be seen off the point.

The new, taller light was built at the end of the point by Orlando M. Poe. Its third-order Fresnel lens was made by Henri Le Paute of Paris, France, and provided a visibility of about 25 miles (40 km). Pat Garrity, the former keeper of the Old Presque Isle lighthouse, lit the light for the first time at the opening of the 1871 navigational season. Garrity served at the new lighthouse until 1885, when he became the keeper of the harbor range lights. His wife, Marg, daughter Anna, and three sons, Thomas, Patrick and John, all served as keepers in the area.

In 1890 a steam-operated fog signal was installed. A 2,400-foot (732 m) tramway was also authorized by the Lighthouse Board. It ran from the lighthouse to the north end of the dock and to the dock, on the west side of the north bay. The trams were used to transport coal, oil and other supplies until the mid-1940s.

This 113-foot (34.5 m) lighthouse is the tallest on the Great Lakes. From inside the lantern you can see for miles in every direction. You can also see the dangerous reefs partially hidden under the water and understand why this lighthouse still functions today.

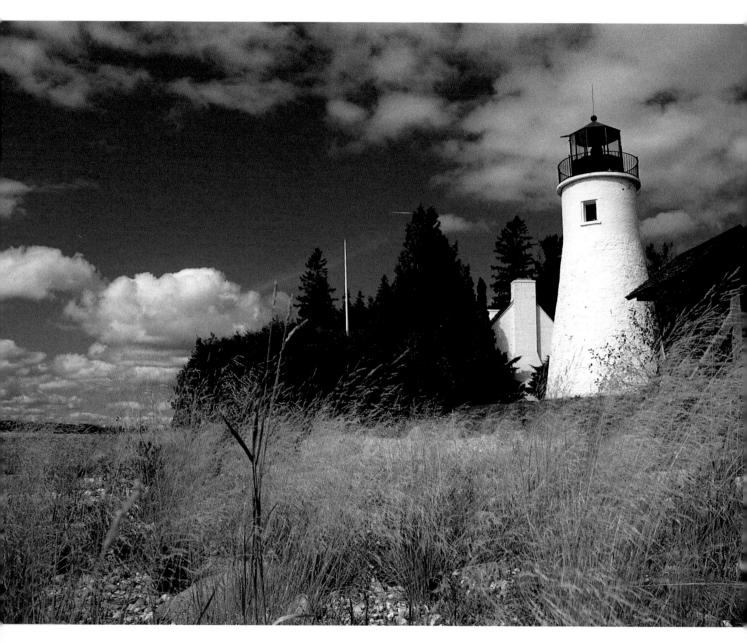

50

Old Presque Isle

MICHIGAN

The name Presque Isle is French and, literally translated, means "almost an island." There are quite a few peninsulas throughout the Great Lakes that bear this name. In the 1830s, Presque Isle Harbor was often used for refuge from storms and as a refueling station for steamships. By 1840 the harbour had docks, a sawmill, a store, barns and several shanties owned by lumbermen and fishermen. It was a busy community.

On July 5, 1838, the U.S. government appropriated $5,000 for the building of a lighthouse at the harbor's entrance. Building materials were brought in by boat. The 30-foot (9 m) tower, built by Jeremiah Moors of Detroit, was finished in 1840. The walls were 4 feet (1.2 m) thick, and hand-hewn stone steps spiraled up to the top. The first keeper, Henry Woolsey, served until 1849. The last keeper was Patrick Garrity. In 1869 the government built range lights across the harbor from the lighthouse. A year later, the new, taller light was built and the old lighthouse was abandoned.

At the turn of the century, A.C. Stebbins purchased the lighthouse for $75 at a tax sale to use as a picnic area for people staying at his hotel. In the 1920s all that remained was the foundation hole of the keeper's house and the tower's stone staircase, but using pictures to guide him, Stebbins rebuilt the tower.

Stebbins's son, Francis, continued restoration and in the 1940s renovated the keeper's dwelling as a cottage. In the 1950s he decided to open a museum at the lighthouse and salvaged the lantern from the Fox Island lighthouse to install on the Old Presque Isle tower. By 1965, restoration to the top of the lighthouse was complete. However, the U.S. Coast Guard deemed it a non-chartered light and illegal to use. Francis's son Jim inherited the lighthouse in 1967.

In 1979, the Coast Guard removed the gears that allowed the light to rotate. The bulb was removed and the lighthouse was extinguished for good ... or so people thought.

In May of 1992, the light appeared mysteriously relit, in spite of it having no electricity. Lorraine Paris, who became caretaker of the museum with her husband, George (who died in January 1992), believes that he is returning to the place he loved. Lorraine saw the light across the bay every night for one-and-a-half years before she told anyone. Soon other people saw it too, including the harbor master. The Coast Guard could not explain it and Jim Stebbins is reluctant to label this phenomenon as a haunting but he admits that at certain times it does look as if the light is on.

The museum is especially interesting as it is a "hands-on" museum. You can "shoot the sun" with an old brass sextant or play the pump organ. Antique nautical instruments and tools include a ship's wheel, binnacles and compass, a barometer, foghorns, marlin spike tools, a capstan, deadeyes, anchors, propellers, a windlass, cleats and Fresnel lenses. The cottage is furnished with antiques of the 1800s and early 1900s.

Outside, in front of the lighthouse, is a bronze bell taken from the old Lansing City Hall clock tower. Cast in 1896, it weighs 3,426 pounds (1554 kg) and is 60 percent heavier than the Liberty Bell. Visitors love the bell, and on a summer's day it may be rung as often as five hundred times. In 1995 Jim Stebbins sold the lighthouse and museum to the local township, which continues to operate it.

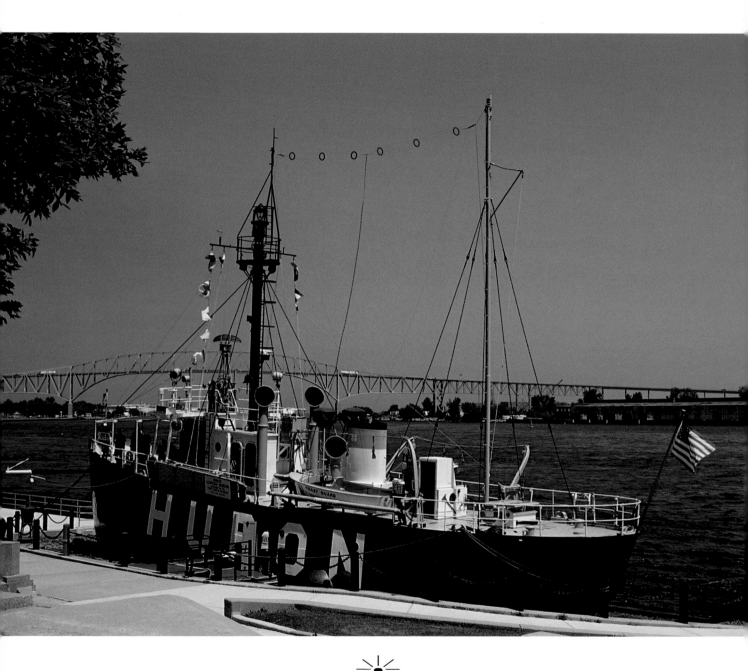

The Huron Lightship

MICHIGAN

A lightship had the same function as a lighthouse but had the capability of being moved from location to location. In areas where frequent groundings occurred, the U.S. Lighthouse Service used manned lightships instead of lighted buoys because they were more reliable. There were eighteen locations for such lightships between 1893 and 1940.

The *Huron* lightship was commissioned in 1921 for the United States Bureau of Lighthouses and began its service as a relief vessel for other Great Lakes lightships. She is 97 feet (29.6 m) long with a 24-foot (7.4 metre) beam and could carry a crew of eleven. On a clear night her beacon could be seen for 14 miles (22.5 km). After serving in northern Lake Michigan, the *Huron* was assigned to the Corsica Shoals in 1935. These shallow waters, located 6 miles (10 km) north of Port Huron, were the scene of frequent lake-freighter groundings in the late nineteenth century. The first light station assigned to this location was set up in 1893. Lightships were originally built for the Lighthouse Service, but on July 7, 1939, the Bureau of Lighthouses was taken over by the U.S. Coast Guard.

After 1940 the *Huron* was the only remaining lightship on the Great Lakes. In 1970 the Coast Guard retired the lightship from service, and she was presented to the City of Port Huron in 1971.

The *Huron* is now a marine museum. The restoration of the lightship took six years under the leadership of Captain Ted Richardson and a group of dedicated volunteers. She is nestled on parkland right at the edge of the St. Clair River. From a distance the large white letters — HURON — stand out on the black hull. Inside, the cabins have been refurbished to their working-day decor. Rope-wrapped stairwell railings provide a grip for climbing the narrow stairs. On display in the hull and cabins are a wide variety of items including a knot board, a flag board, code boards and brass artifacts.

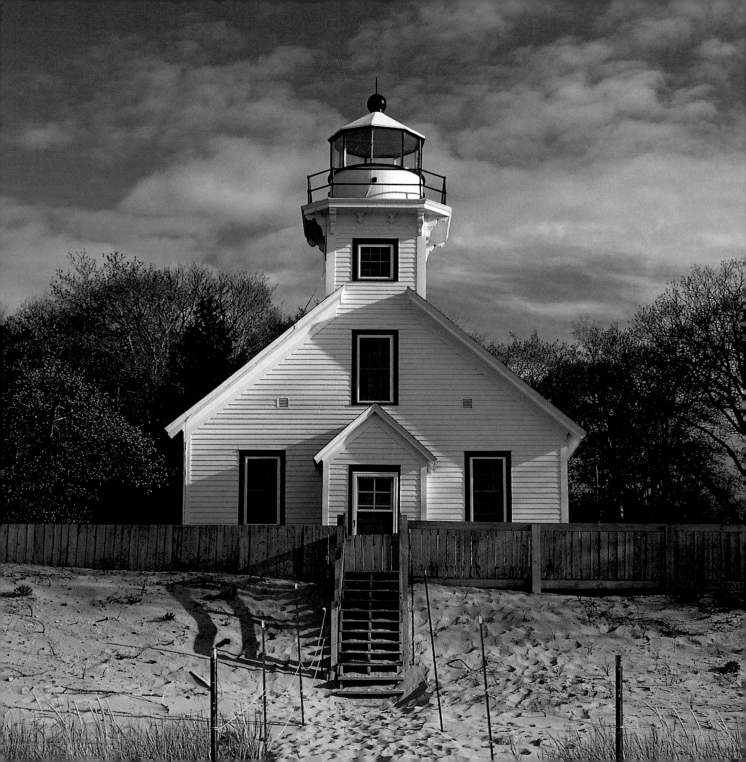

Old Mission Point

MICHIGAN

Built right on the 45th parallel, Old Mission Point lighthouse is located exactly halfway between the equator and the North Pole. In the 1850s, shipping on Grand Traverse Bay had grown substantially. The lighthouse on Old Mission Peninsula was built to warn of this shallow rocky point. In 1858 Congress appropriated funds, but the lighthouse was not completed until 1870.

Its site, cut out of the hardwood forest around it, is marked by a low, board fence that has turned gray from weathering. The small, two-story clapboard keeper's house has a short, square tower that extends up from the roof at the front. The octagonal lantern is surrounded by a gallery. The white tower and house are trimmed in black.

The first lightkeeper was Jerome M. Pratt, who kept a detailed journal of passing ships. On his first day there were five vessels, two schooners, two steamers and seventy-five sailing ships. Pratt was followed by J.W. Lane, Joseph Green and Emil C. Johnson.

In 1933 the old kerosene-burning lamp was replaced with automatic lights on a tower nearby. Later the lights were mounted on an offshore buoy.

The lighthouse has been owned by Old Mission Township since 1948. It is now part of Lighthouse State Park and is a most picturesque spot. A boardwalk has been constructed in front of the building so tourists and photography buffs will not get sand in their shoes. Beyond the boardwalk is a beautiful sand beach with rocks at the water's edge.

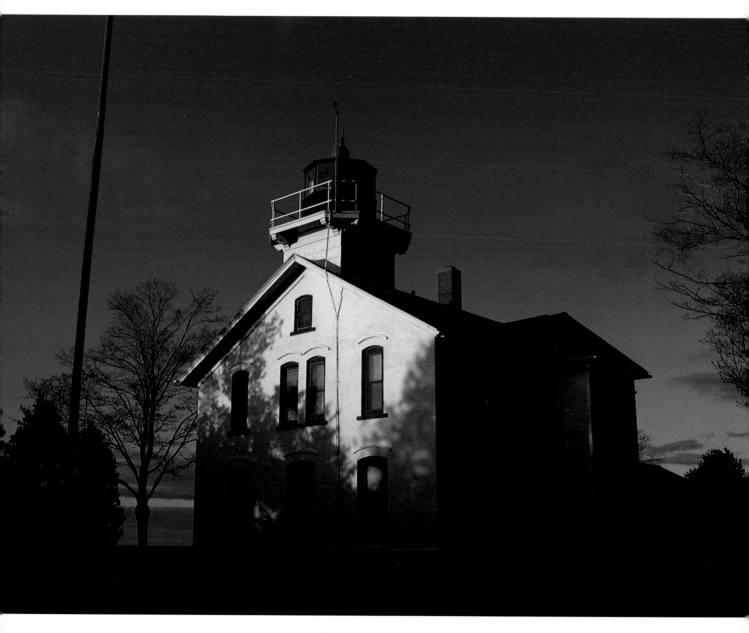

Grand Traverse

MICHIGAN

The first lighthouse here was Cat's Head lighthouse, built on the order of President Millard Fillmore in July 1850. The brick tower with its separate lightkeeper's quarters was built south of the present site.

In 1852, the keeper was U.S. Deputy Marshall Phil Beers. He had some interesting times in this remote location. Once, he was invaded by the subjects of "King" Strong, who ruled the Mormon colony 25 miles (40 km) to the north on Beaver Island. During the invasion he lost his provisions, fishnet and lighthouse equipment. Fortunately much of the equipment was undamaged, including the imported Fresnel lens. Sometime after his house burned and the tower was torn down because it was weakened by erosion.

The Grand Traverse lighthouse sits at the end of Leelanau Peninsula. When first built it would warn passing schooners, laden with grain, meat and whiskey, of this outcropping of land; it also marked the entrance to Traverse Bay. During the last part of the nineteenth century it served mostly steamships. Today it is part of Leelanau State Park.

The present three-story yellow-brick house with its rooftop tower and copper-capped lantern was built in 1858 by the U.S. Lighthouse Service. The square tower, now covered with white pressed-metal sheeting, rises about one story above the housetop. The octagonal lantern originally burned kerosene. In 1870 it received a fourth-order Fresnel lens to replace a smaller lens. The light stood 47 feet (14 m) above the lake level and could be seen for 12 to 17 miles (19 to 27 km).

In 1899 a fog signal was installed here. In 1900 the house was converted to a two-family dwelling, and in 1916 a new kitchen was added. The porch wings were added and electricity was installed in 1952. In 1972 the building was closed and an automatic light tower was erected. Then in 1986 it was opened to the public as a museum. The museum and grounds are maintained by the Grand Traverse Lighthouse Foundation.

Down the front slope to the beach are steps with a stone balustrade leading to the rocky shore. About halfway down is a landing with cement-slab benches inset on either side. There is also a fieldstone-walled flower bed built into the hillside beside the steps. A unique round flower bed beside the house also has a fieldstone wall, but the stones are smaller. Above it are stone-encrusted arms that attach to a center post and form a crown shape.

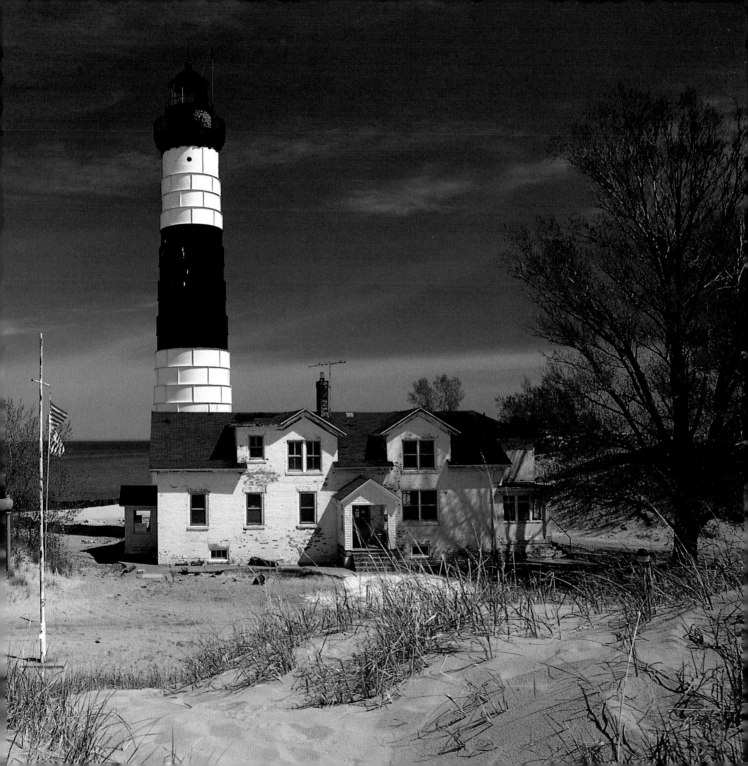

Big Sable Point

MICHIGAN

This lighthouse stands in Ludington State Park. Access to the lighthouse is obtained by a 1.5-mile (2.4 km) hike along the rolling sand dunes of the shoreline or along the lighthouse trail in the park.

The Big Sable Point lighthouse was the first of the Tall Lighthouses built on the Great Lakes. This 112-foot-high (34 m) tower, covered in black and white banded steel, is impressive. The walkways around the lantern and the dome are painted black. The decagonal lantern has six glass panels and four steel panels. The steel panels face inland and are painted black, to keep the light from shining over land. The lantern was originally equipped with a third-order Fresnel lens. That lens is now on display at the Rose Hawley Museum, in downtown Ludington. The light was automated in 1985 and given a new 300-millimeter plastic lens.

When the tower was built in 1867, the exterior was brick. By the early 1900s the tower had deteriorated greatly. To repair it, it was encased in iron plates, and cement was poured between the plates and the original brickwork. After this, the middle section of the tower was painted black, as a day marker.

The tower is connected to a white, two-story brick house by a connecting covered walkway. Its quaint second-story dormers look out over the lake. Both the tower and the house were built on stone block foundations. Originally the house was yellow brick. A redbrick addition was added some time later. A crumbling cement walkway, partially covered by sand, leads around the buildings. There is a steel-pylon breakwater in front, along the sandy beach, to help prevent erosion.

The Big Sable Point Lighthouse Keepers Association offers tours of this historic site, and bus tours are available from Ludington. Money raised by the association goes toward the restoration of the lighthouse.

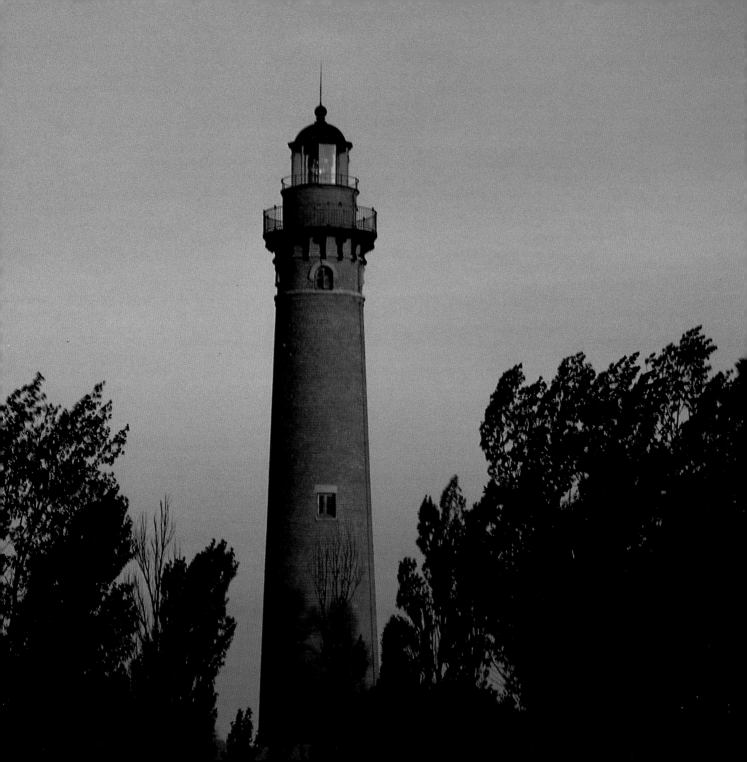

Little Sable Point

MICHIGAN

Although tucked in among 50-to-80-foot (15 to 24 metre) sand dunes on the shore of Lake Michigan, this 107-foot (32.6 m) tower seems to dwarf everything around it. It was built in 1874 and is a tall redbrick tower that tapers slightly as it rises. This lighthouse is very similar in style to the Tall Lighthouses. Below the top is a cement ring that juts out from the brick. Above this are four windows with curved tops and cement lintels that project out above the windows to both frame and protect them. The outer gallery around the lantern is supported by black wooden braces.

The tower is topped by a decagonal lantern, which still houses its original third-order Fresnel lens. The lamps were originally fed with oil and then kerosene. In 1954, they were replaced with electric light.

The lightkeeper's dwelling is long gone. All that remains of it is the foundation, sticking out of the sand. In front of the tower's base, large rocks help prevent erosion.

The tower is located in the Silver Lake State Park. To get to it you have to walk through steep dunes. Although the light is in a fairly remote area of the park, there is a public beach at its base and it is a favorite spot at sunset for both young and old. There is a lot of camping and recreational activity in and around Silver Lake, but the most noticeable pastime is dune-buggying on the nearby 80-foot (24 m) sand dunes.

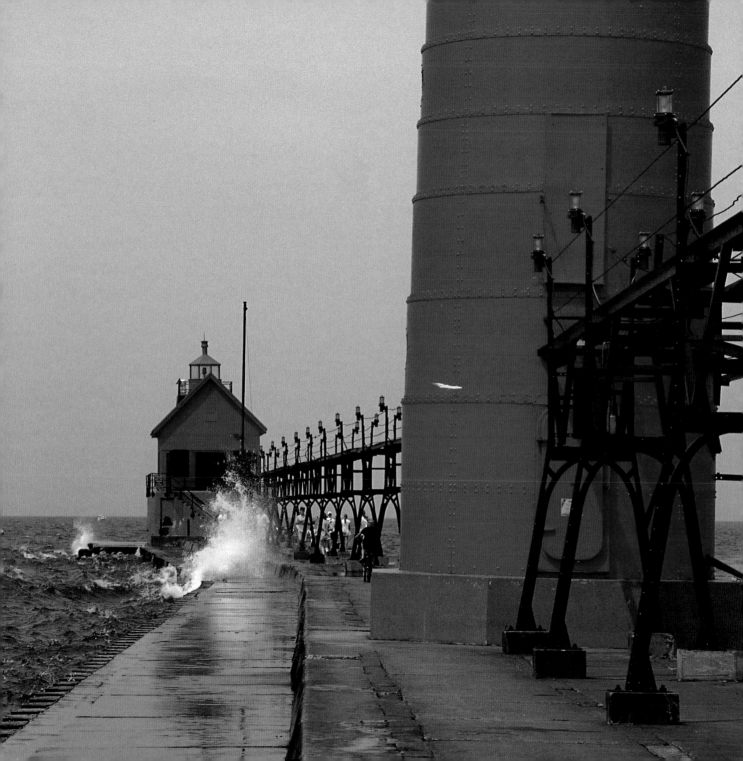

Grand Haven

MICHIGAN

The two Grand Haven lights are built on a huge cement pier that juts out into the water. They are connected by a long, impressive catwalk. The south light sits about 200 feet (61 m) out on the pier, which has a pointed prow shape at the front to cut the impact of incoming waves. On this base sits a square, red steel building with a small tower jutting slightly above the rooftop. This lighthouse also houses the fog signal.

In from this, about 50 feet (15 m) out onto the pier, is the south pier inner light, which stands 51 feet (15.6 m) high. This light was originally constructed on shore in 1839, then in 1905 moved and rebuilt in the water. The circular steel tower, railing, lantern and cap are all painted red. The catwalk was built to allow the lightkeeper to safely move between the two lights in stormy weather.

Grand Harbor is a resort town. Tourists can fish from the pier, go swimming, enjoy the sun and sand, or boat in the area. Nearby Grand Haven State Park has seemingly endless sand beaches and even has campgrounds on the beach.

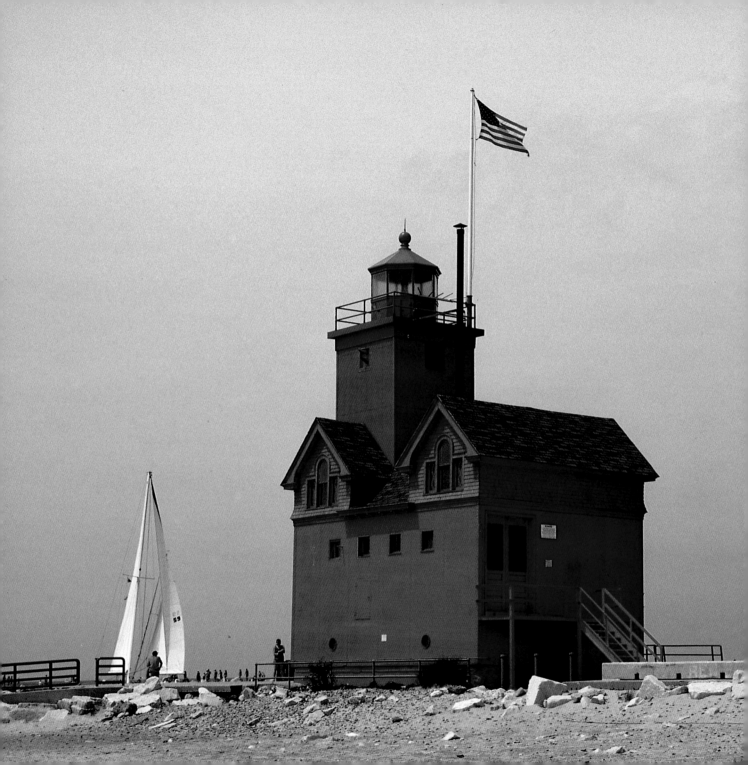

Holland Harbor

MICHIGAN

When seeking a location for his followers in 1847, Reverend A.C. Van Raalte of the Netherlands was attracted to this area because of the potential for using Black Lake (Lake Macatawa) as a harbor. However, this lake's outlet to Lake Michigan was blocked by sandbars and silt. Van Raalte appealed to Congress for help. The channel was surveyed in 1849, but was not successfully opened due to inadequate financial support. Frustrated, the Dutch settlers dug the channel themselves. On July 1st, 1859, the small steamboat *Huron* put into port.

Here, in 1886, the government established the harbor's first lifesaving station. By 1899 the channel had been relocated and harbor work completed, spurring business and resort expansion. In 1900, over 1,095 schooners, steamers and barges used the harbor.

The lighthouse was built at the end of the pier in 1907. It marks entry from Lake Michigan into the channel that leads to Lake Macatawa. Beyond the lighthouse and channel entrance, on both the north and south sides, stone-and-cement breakwaters and piers have been built to help protect the channel entrance in stormy weather. There are channel-light markers at the end of each pier to mark the entranceway into the channel.

This lighthouse reflects the Dutch influence in the area. It is a large red building with a black smokestack. Its nickname, "Big Red," suits. The twin-gabled roofs of the three-story keeper's house are connected by a middle roof and covered by gray asphalt shingles. The top story is sided with cedar-shake shingles; at this level, the middle window is rounded at the top and flanked on both sides by rectangular windows with diamond panes. There are four square windows on the second level; porthole-style windows light the first level.

The lighthouse was covered with steel plates in 1936, perhaps to slow down deterioration by weather. The long, skinny, black smokestack reaches up from the middle of the house to a height equal that of the lantern cap. The square light-tower was added in 1936, extending up two stories from the western rooftop. A flagpole rises from one corner of the iron railing atop the tower, and from it flies an impressive American flag. The original Fresnel lens is on display at the Holland Municipal Museum in downtown Holland.

With its clean, plentiful sand beaches and its large, well-protected harbor, it is easy to understand why tourists flock here each summer. Visitors also come in the spring for the annual Tulip Festival.

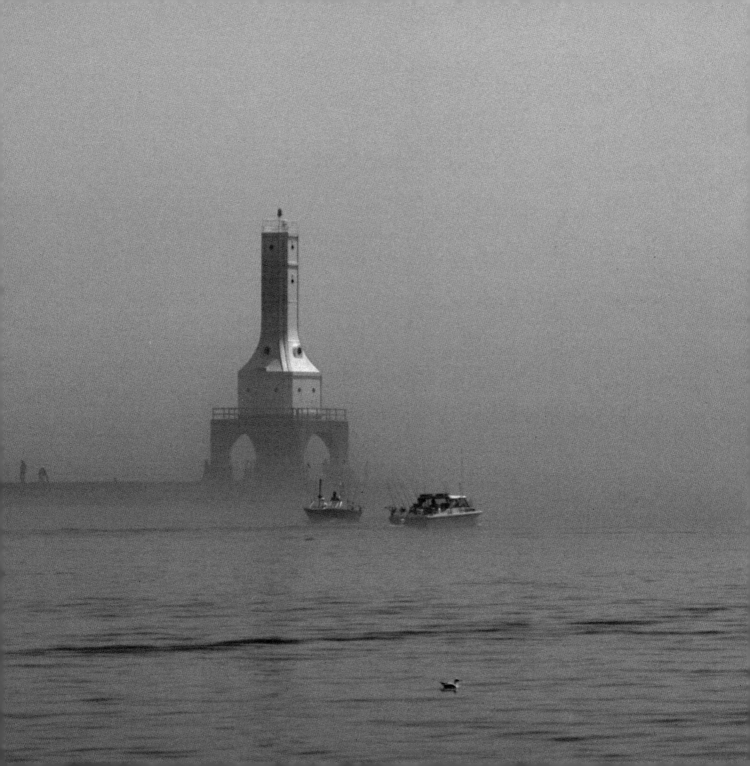

Port Washington Breakwater

WISCONSIN

The original lighthouse for Port Washington Harbor was built in 1860 on the rise of land behind the harbor. The small tower that housed the light extended up from the roof of the lightkeeper's house. In 1889 the first breakwater light was built to replace the lighthouse and make the harbor more visible to ships. In 1934 the U.S. Coast Guard removed the tower from the lightkeeper's house.

The Port Washington Harbor now has two cement breakwaters that extend into Lake Michigan and help to protect the harbor. The new light tower was built in 1935 at the end of the northern breakwater. Its structure is unique; the foundation is made of cement block in the water; the base is a 20-foot (6 m) cement arch that sits on the foundation. The square, white steel tower is centered on the base and rises about 40 feet (12 m) above it. On the first level of the tower is a door flanked on both sides by porthole windows. Above the first level, the tower curves and tapers in and then straight up. This straight section has a porthole window at the top and the bottom. Instead of a lantern, the tower is topped by a modern red beacon.

In 1993 the Port Washington Historical Society signed a thirty-year lease and began restoration of the original 1860 lighthouse.

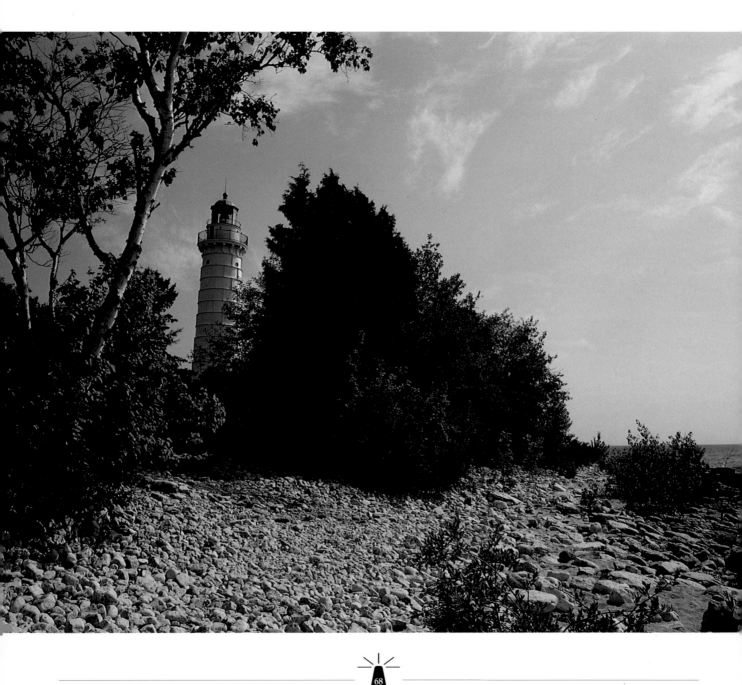

Cana

WISCONSIN

To reach the Cana lighthouse, nestled on its own island, you must walk across a low, limestone causeway that has been naturally formed by storms. This island is particularly vulnerable to changes in water level; at times the causeway is even under water. The working tower is not open to the public and the house is a private home, but the lighthouse grounds are open to visitors during specific hours.

The Cana lighthouse, built in 1869, warned ships of this rugged shoreline and the treacherous reef off the shore. It housed a keeper, his assistant and their families. It has been modified several times over the years, the last time in the 1940s. The focal plane of the tower is 89 feet (27 m) above the water level. Originally the tower was the same yellow brick as the house but it was encased in iron sheets in the early 1900s, probably to prevent deterioration. The base walls are 4 feet (1.2 m) thick and 102 steps lead up the spiral staircase to the lantern. The lantern still has its original Fresnel lens, which stands nearly 5 feet (1.5 m) tall. Its visibility is 18 miles (29 km).

The two-story brick keeper's house had a main entry on the west side as well as a tower entry. The first floor had four rooms, a living room, a dining room, a bedroom and a keeper's office. Since then, the tower entry has been sealed, the bedroom has been converted to an entry room, and a door has been added on the south side. There are four more rooms on the second floor. At the back is an original brick lean-to, which has been divided into a small pantry on the south side and a larger summer kitchen and entry on the north side.

In the early days, supplies were brought to the lighthouse by boat. The lantern first used lard or whale oil, then kerosene, acetylene gas and then electricity supplied by a generator. Power lines were brought in in 1960, and the light is now automated and is operated by the Coast Guard and maintained by the Aids to Navigation team at Green Bay. The lighthouse is now a National Historic Site, and the island and buildings are maintained by the Door County Museum.

A wide, rough path meanders through wild raspberries and trees up the lighthouse grounds. A walkway leads up to the lighthouse past a white-painted brick outhouse with a red shingled roof. Next is a hexagonal, hand-hewn, stone-block oil bunker built soon after the turn of the century for storage of flammable fuel. As lard oil and whale oil were relatively safe to handle, they had been stored in the house or the base of the tower. Today, the oil bunker houses a small museum. The cement walkways and the stone fences that frame three sides of the island were built in the 1920s.

The lighthouse appears to modern visitors much as it did at the turn of the century. In spite of its rather remote location, this spot receives many tourists and is a good place to learn about early life at a lighthouse.

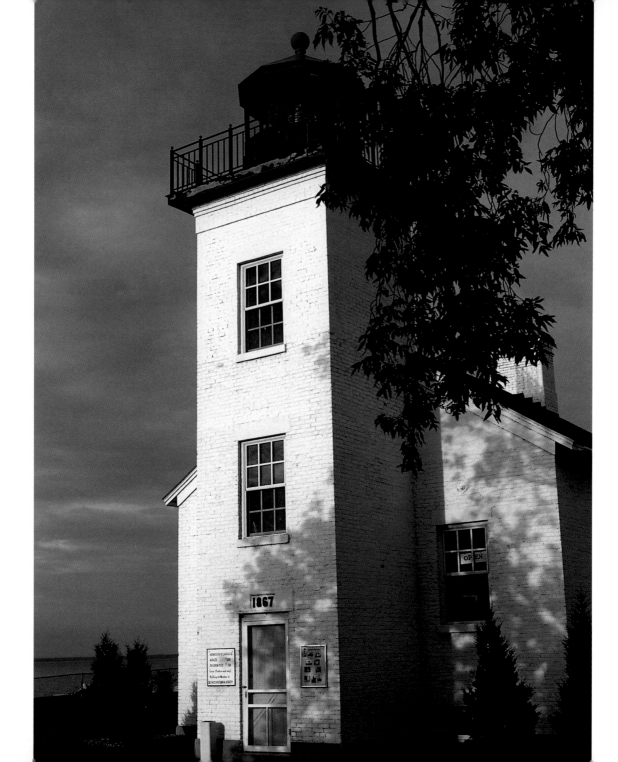

Sand Point

MICHIGAN

Sand Point lighthouse was built in 1867 at Escanaba. An 1886 fire killed the first lightkeeper, Mary Terry. The lighthouse was repaired, and in 1940 the U.S. Coast Guard converted it to a family residence for their personnel. Then in 1986 the Delta County Historical Society signed a thirty-year lease for it and restoration soon began. In 1987 the aluminum siding and sheet insulation were removed. The second floor was gutted and the roof was lowered 4 feet (1.3 m), to its original height. By 1988, masonry work was underway to rebuild the tower and restore the window openings.

In 1989 the lighthouse's platform, lantern and lens were replaced. The new lantern came from Poverty Island and the Fresnel lens came from Menominee. On July 18, 1990, there was a special dedication ceremony to open the restored lighthouse and museum. The restored two-story yellow-brick keeper's house and the square, three-story tower were painted white. The attached tower has a door at the front and two large windows with small panes of glass to illuminate its circular iron staircase. The decagonal lantern has a square gallery with a black iron railing around it. The lantern is black at the bottom and is capped by a red dome.

The well-kept west side of the yard, lined with good-sized Manitoba maples, adds a homey appearance to the lighthouse. In the yard is an old boat winch that was used to pull boats up and over the rocky shores of Poverty Island. There is a radio tower and aerial on the south lawn of the property.

Peninsula Point

MICHIGAN

Unfortunately, all that remains of the lighthouse at Peninsula Point is the square, yellow-brick tower. The 1865 lighthouse was built on the grassy point to mark the peninsula of land and shoals that divide Little Bay De Noc and Big Bay De Noc, in the days when lake traffic was increasing due to growing iron-ore exports.

Early life at Peninsula Point was hard. The road to the lighthouse was impassible by wagon, so the lightkeeper's children had to walk the 4 miles (6.4 km) to school each day. The family purchased groceries in Escanaba. In summer they travelled by boat, and in winter, over the ice by horse-drawn sleigh. But during fall freeze-up and spring break-up, travel was impossible, so they had to stock up on provisions. By the early 1900s the site included a barn, a woodhouse, an oilhouse and an outhouse. The tower had an attached keeper's house and there was a summer kitchen.

In spite of this light, ships still had trouble locating the peninsula, so the Minneapolis Shoal light was built. When it was activated in 1936, the Peninsula Point lighthouse became obsolete. While it sat empty, it became a playground for local teenagers. Then in 1959 a fire gutted the structure, and today all that is left is the tower and the remains of the cement walkways to the other buildings.

The Peninsula Point lighthouse tower is now part of a beautiful, well-kept picnic area that belongs to the Hiawatha National Forest. Although the tower was gutted, you can still walk up its forty-one steps to the top for a wonderful view. There is a square gallery enclosed by a black iron railing around the decagonal lantern. The base of the lantern and the dome are black. The tower has a door and four windows, two facing south and two facing north. All of these windows now have iron bars over them to prevent accidents. To the west you can see Escanaba, to the south, the Minneapolis Shoal light, and to the east, Fayette.

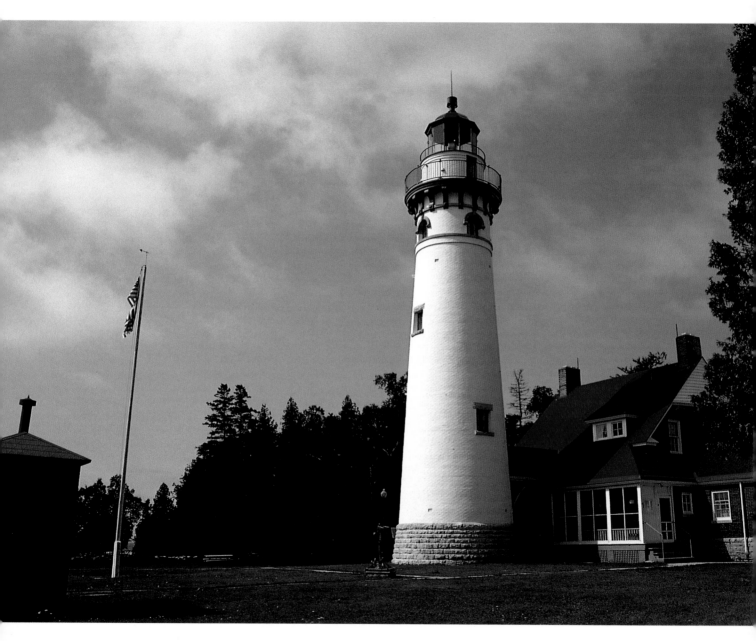

Seul Choix Point

MICHIGAN

The Indian name for this point of land was Sishawa. As it was the only place where ships could find safety in stormy weather before entering the Straits of Mackinac, the French renamed it Seul Choix, which means "only choice."

Lake traffic in this area increased as more iron ore was shipped out of Escabana. In 1886 the Lighthouse Board in Washington, D.C., asked for $15,000 to build a light station at Seul Choix to help light the 100 miles (161 km) of Michigan shoreline between St. Helena (near the Straits of Mackinac) and Poverty Island (off the tip of the Garden Peninsula).

The light station was completed in September 1895 at a cost of $20,000. It included the tower, quarters for two families, a steam fog-signal and boiler house, a stable, a boathouse, two docks and a tramway to move supplies from the boats to the station.

The Seul Choix Point lighthouse features a large, two-story redbrick keeper's house attached to a round, 79-foot-8-inch (24 m) brick tower, painted white. Both are built on a stone-block foundation. As this lighthouse has many features in common with the Tall Lighthouses, it is possible that it was built from the same or similar plans. The windows have cement lintels and green trim. The tower gallery is supported by carved wooden braces. Directly below these are four windows with semi-circular tops, below which are two rings of unpainted cement that jut out from the tower.

The tower is surmounted by a decagonal cast-iron lantern. Originally it housed a third-order Fresnel lens, but in 1972 this was removed and donated to the Smithsonian Institute and replaced by a fully automated airport beacon, which has a visibility of 17 miles (27.4 km).

In 1973 the Coast Guard discontinued care of the Seul Choix Point station and in 1977 allowed the Michigan Department of Natural Resources to buy the property. The land and buildings were declared a Michigan Historic Site and a National Historic Landmark. The grounds were then leased to Mueller Township for use as a public park. Soon after, the Gulliver Historical Society took over. They converted the fog-signal building into a historical museum, restored the tower and house, refurbished the house with furnishings from the early 1900s, and continue to make improvements.

You enter the keeper's house through a sunporch. To enter the tower you go through an arched doorway inside the house. After climbing the eighty-nine steps you are rewarded with an extraordinary view of Lake Michigan. Most days you can see as far as Beaver Island.

The large rock in front of the lighthouse has an interesting story. Long ago, a few local children built a raft and, unbeknownst to their parents, attempted to sail out to Beaver Island. A storm came up and the children were stranded on Gull Island. Pieces of the raft washed ashore on the mainland. Funeral services were held for the children, who were presumed drowned, and their names were carved into the huge rock in front of the lighthouse. A few weeks later, the Native people who rescued the children returned them home, much to everyone's amazement.

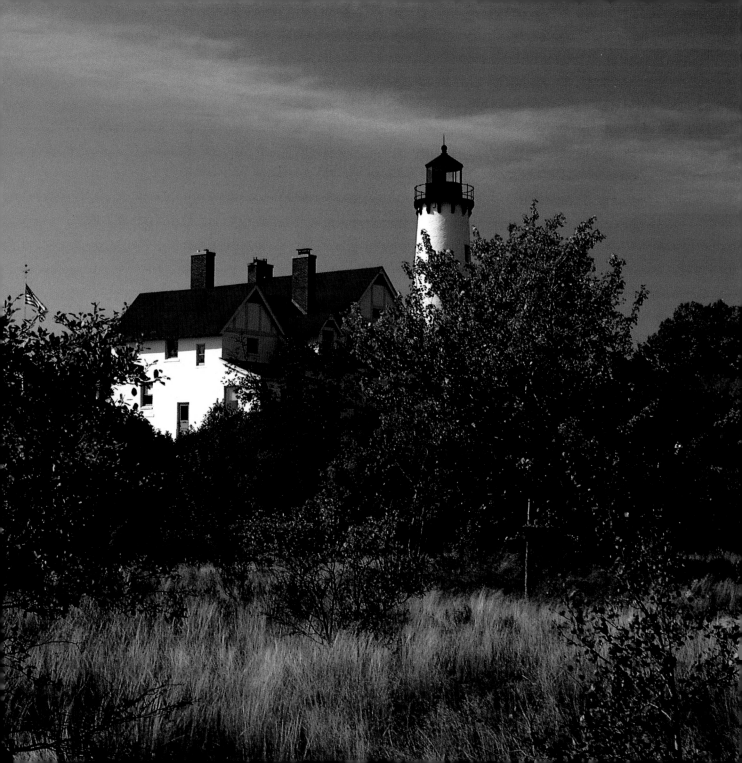

Point Iroquois

MICHIGAN

The United Stated Lighthouse Service established a contract in 1854 for the building of a lighthouse at Point Iroquois to guide ships safely from the open waters of Lake Superior into the St. Mary's River. To the north, toward Gros Cap, rocky outcroppings loomed underwater. On the American side of the narrow channel, gravel and sand bars awaited careless navigators. The gray stone lighthouse, erected in 1857, was attached to a one-and-a-half-story keeper's dwelling. It had a fourth-order Fresnel lens with a flash every thirty seconds.

This point of land is the site of the historic battleground where the westward invasion by the Iroquois was halted by the Chippewa in 1662. French-Canadian voyageurs paddled canoes past Point Iroquois heavily laden with furs and supplies. On June 27, 183l, Henry Rowe Schoolcraft led an expedition from this point to assist trade and gain favor with the warring bands of Chippewa and Sioux in the Upper Mississippi Valley.

By 1870 shipping on the Great Lakes had become an important industry. In that year, a second lighthouse was built to replace the first one. In the early 1900s the dwelling was enlarged to accommodate the head keeper, his two assistants and their families.

The early light used kerosene, and the lens was rotated by clockworks that had to be wound every four hours. In the 1900s a steam-whistle fog signal was added, powered by coal-fueled boilers. It had a five-second blast followed by twenty-five seconds of silence. In the 1920s the boilers were replaced with two huge diesel engines.

The keeper and assistants were inspected quarterly. Inspections were supposed to be a surprise, but often the lightkeepers would be warned of the coming inspector. The tower was whitewashed in the early summer and everything else was either varnished, painted, polished or shined. The keepers and their families dressed in their best finery to meet the inspector, who checked the tower, the fog signal, the quarters, the outbuildings and the keeper's logbook. The most efficient keeper received an efficiency pin and was authorized to fly the E Flag during the year. The E Flag flew many years at Point Iroquois.

In her book *Lighthouse Memories*, Betty Byrnes Bacon, a lighthouse keeper's daughter who grew up at Point Iroquois, recounts vivid stories of her fascinating life at the lighthouse. At first the children here could not attend school, but eventually the government set up a school right at the station for the children of the three keepers and those of a nearby fisherman. The Lighthouse Service paid the teacher's salary and room and board.

The lighthouse operated for ninety-three years, ceasing operation in 1962 when an automated light was erected in the channel. In 1975 the Point Iroquois lighthouse was placed on the National Register of Historic Places. Today the lighthouse is part of the Hiawatha National Forest. Renovation of the site was begun in 1983 by the Bay Mills–Brimley Historical Research Society and the U.S. Forest Service. Since then they have worked to restore the lighthouse, which now includes a museum. You can also climb the seventy-two steps of the tower to look out over Lake Superior.

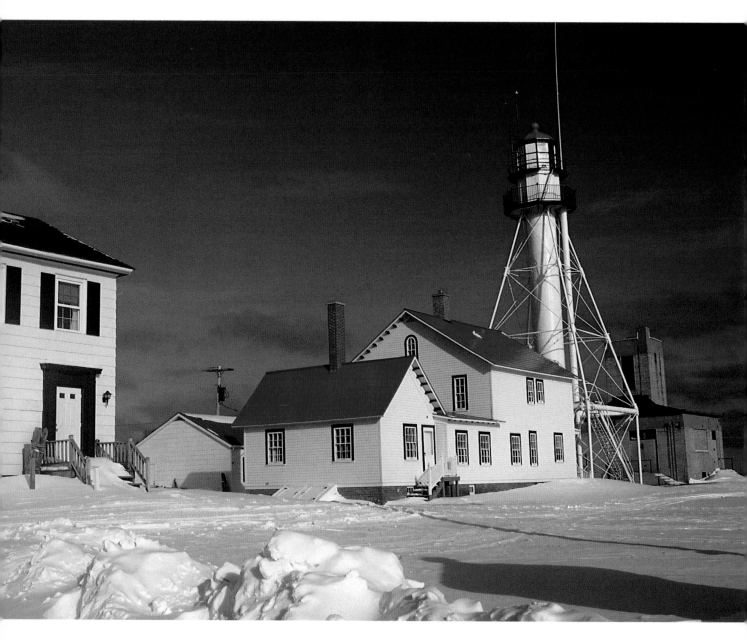

Whitefish Point

MICHIGAN

In the 1800s there were many wrecks off Whitefish Point, which earned the nickname the Graveyard of Superior. In 1847, a newspaper reporter, Horace Greeley, accused the U.S. government of manslaughter for not having erected a lighthouse on the point. Over seventy major shipwrecks have been recorded in these waters, including the sinking of the *Edmund Fitzgerald.*

This point is a crucial spot because it marks a course change for vessels navigating the treacherous coastline to and from the St. Mary's River. During ferocious storms on Lake Superior, ships would often seek safety in the relatively calm waters of Whitefish Bay behind the point. The construction of a lighthouse on the point would help mark the location of the bay as well as warn of the treacherous shoals off the point.

The Whitefish Point lighthouse was built in 1849 and was one of the two earliest lights on Lake Superior, the other being the Copper Harbor lighthouse, also built that year. As well as assisting in lake navigation, the lighthouse was an early stopping place for Native travelers, voyageurs and Jesuit missionaries.

The present iron tower replaced the brick tower in 1861. The tower is 80 feet (24.4 m) tall and appears very modern with its metal skeletal braces, but it is actually over 130 years old. The octagonal lantern is capped with a red dome. Its Fresnel lens has been replaced with an aerobeacon. Since 1971, the light, fog signal and radio beacon have been automated and controlled from Sault Ste. Marie by the U.S. Coast Guard.

There is a two-and-a-half-story lightkeeper's residence with an enclosed catwalk from the second story to the central shaft of the tower. The keeper's house is now the Great Lakes Shipwreck Museum, operated by the Great Lakes Shipwreck Historical Society.

In November of 1975 the *Edmund Fitzgerald* sank mysteriously during one of Superior's worst storms. The ore carrier was heading for the safety of Whitefish Bay, but with her radar disabled and the light and the radio beacon on Whitefish Point out because of the storm, she instead headed north to find protection behind Caribou Island. Unfortunately, the storm was worse there and she encountered raging 30-foot (9 m) waves. She sank in Canadian waters and disappeared from radar. The Coast Guard and other ships in the area searched for survivors, but none were to be found and no bodies were ever recovered.

After more than twenty years and five diving investigations, the actual cause of her sinking remains unknown. In the summer of 1995 the Canadian Navy made a dive to retrieve the ship's bell, which was donated to the museum at Whitefish Point in honor of the twenty-nine crew members who lost their lives.

This lighthouse receives many visitors, summer and winter. In the winter months a steady stream of snowmobilers make the site one of their favorite rendezvous points.

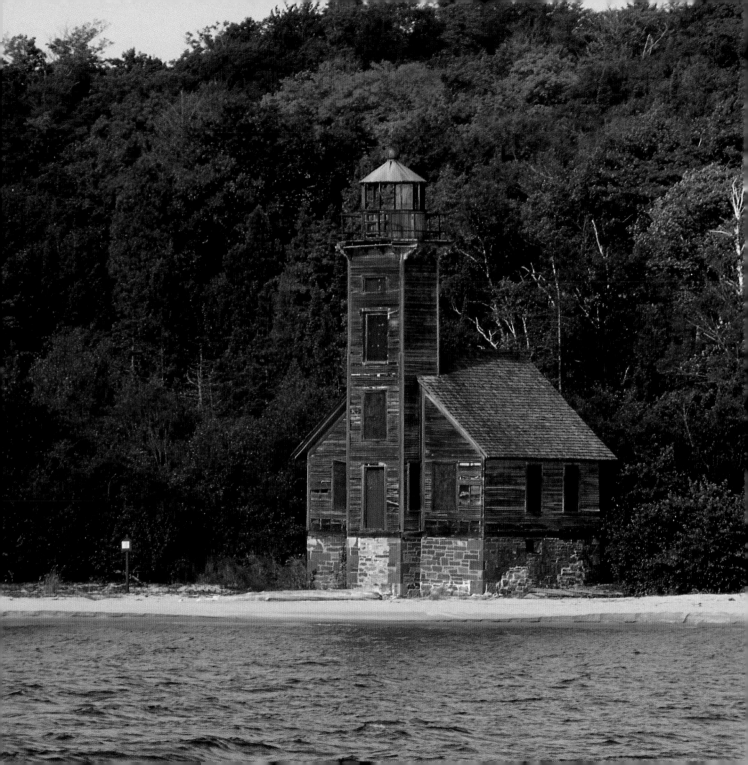

Grand Island East Channel

MICHIGAN

Grand Island is recessed in a bay along the south shore of Lake Superior. The 13,000-acre (5,261 ha) sheltering island creates a natural safe harbor for ships, protecting the port of Munsing. During the mid-seventeenth century, the French explorer Pierre Raddison explored the rocks of the island and the surrounding area. The Picture Rock National Park shoreline has tall rock faces with outcrops and holes in the rock that create high natural arches.

The winds of Superior and the harsh storms, no matter which direction they came from, could cause few problems for ships anchored in this protected harbor. Because of this, it did not take long for a settlement to develop at Munsing Bay. Munsing was a fur and lumber community and it used Lake Superior to ship products out and bring supplies in. Many steamships were already traveling from Sault Ste. Marie to Marquette, and Munsing was the only safe sanctuary from terrifying storms on Superior between the two ports. It also became a departure port for lumber, fish and fur as well as a necessary fuel stop for steamships traveling along the south shore.

With ever-increasing ship traffic on Lake Superior, the Lighthouse Board was pressured to construct a light on the north side of Grand Island in 1856 to warn vessels of its presence. At the same time, better light was needed on the eastern and western channels into Munsing Bay. So, at a total cost of $17,000, three identical white wooden structures were built here.

The East Channel Lighthouse was built on a sandy point along the beach on the southeast shore of Grand Island. An oil lamp was used in the lantern, which was located at the top of a square tower, about five stories high. It was first lit on August 15, 1868.

Frederick Giertz was the first of seven lightkeepers. But in 1907 Congress appropriated $15,000 to replace the lighthouse. A two-story wood-and-brick keeper's dwelling with a steel tower beside it was constructed at Munsing as a front range light. Behind it on the hillside, another smaller steel tower was built to be used as a rear range light. On completion of these, the East Channel light was decommissioned and the lightkeeper was transferred.

Today the East Channel lighthouse can be seen only by boat. It looks like an old abandoned church. The white paint has long since faded away and weathered gray board remains, the once-bright copper roof has long since turned green, and much of the glass in the lantern is broken or gone. Divers frequent a sunken ship in the narrow channel off the point of land here.

The owner and a few private citizens took an interest in the building a few years ago and made some necessary repairs to prevent its collapse. Although it is now abandoned and mostly neglected, the structure still retains its rather stately posture.

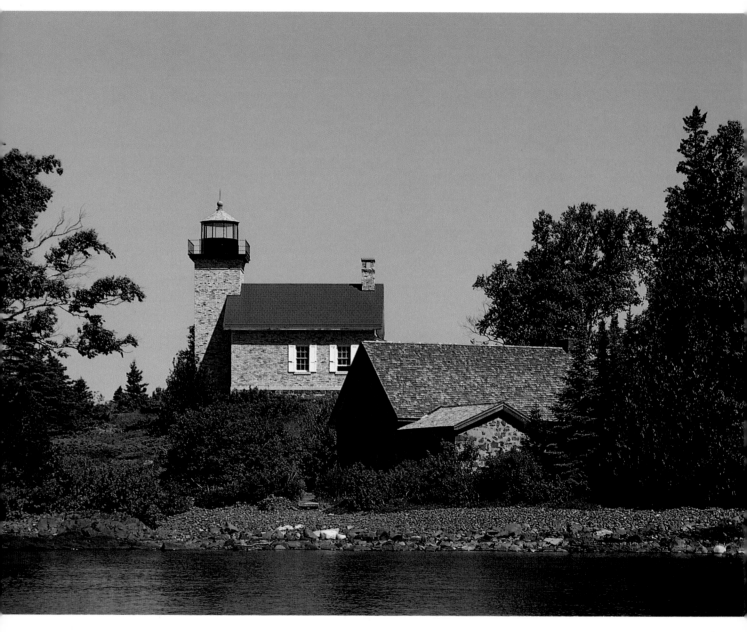

Copper Harbor

MICHIGAN

In 1841, Douglas Houghton's geological reports suggested significant copper deposits on the Keweenaw Peninsula. So in 1843 Copper Harbor became a focal point for early copper exploration. In 1844, looking for copper, the Pittsburgh and Boston Mining Company sank a 40-foot (12 m) shaft on the north shore of Hugh's Point. Then in 1847 Congress appropriated $5,000 for the first lighthouse. In 1849 a stone light tower and a detached keeper's cottage were built at Copper Harbor on Hugh's Point (now also called Lighthouse Point). The original stone cottage is the oldest lightkeeper's house still standing on Lake Superior.

The original tower here was built by Charles Rude. From the original specifications we know that it was a 65-foot-high (20 m) whitewashed tower with six windows. Its walls, made of split stone or hard brick, were 5 feet (1.5 m) thick at the base and 2 feet (0.6 m) thick at the top. It had a soapstone deck with an iron railing, and the lantern had copper panes at the bottom and was capped by a copper dome. A fourth-order lens was installed in 1856.

By 1866, the tower required extensive repairs, as it had been built on conglomerate rock (or pudding stone), which puddles water. The water leaked into the bottom of the tower and caused damage due to freezing. The lightkeeper's cottage also required repairs. Because it would be cheaper to start over than to make extensive repairs, a new tower and keeper's house were built in 1866. Stone from the original tower was used for the foundations for a square, yellow-brick tower with an attached keeper's house. The stairwell to the second floor goes up through the tower. The front of the tower has an outside door at the bottom and two windows to light the tower stairs.

When the lighthouse was built, sperm whale oil cost $2 a gallon. It was used until 1867 when the government began experimenting with other oils such as colza and rapeseed. From 1868 to 1878, lard oil was used at only one third the cost of the sperm whale oil. After lard oil, kerosene was used. The light was converted to acetylene gas in 1919. In 1927 the gas light was moved to a 60-foot (18.3 m) steel tower nearby and the keeper's dwelling was leased privately as a summer home. Approval was granted to electrify the main light in 1937.

In 1963 the point was acquired by the Michigan Department of Natural Resources. Now the 1866 lighthouse is a museum and part of Fort Wilkins State Park, accessible only by boat. Hourly narrated cruises leave from Copper Harbor Marina. While on the peninsula, you get a guided tour of the restored lighthouse and can take a walking trail to the agate beaches or the first copper-mine shaft on the Keewanaw Peninsula.

Hugh's Point has always been particularly dangerous, as strong winds here can push ships onto the rocky outcropping, and during storms and fog, ships would lose their way and end up on the rocks. There have been many shipwrecks in the area, the most recent on December 4, 1989. The *Mesquite*, a U.S. Coast Guard ship that was out collecting buoys, drifted, could not get its engines going, and became hung up on the rocks. An overnight storm put a hole in the ship's hull, so it was left there. It is now part of the underwater reserve of the Keewan Harbor. Everything was left on board, so it makes an interesting spectacle for divers.

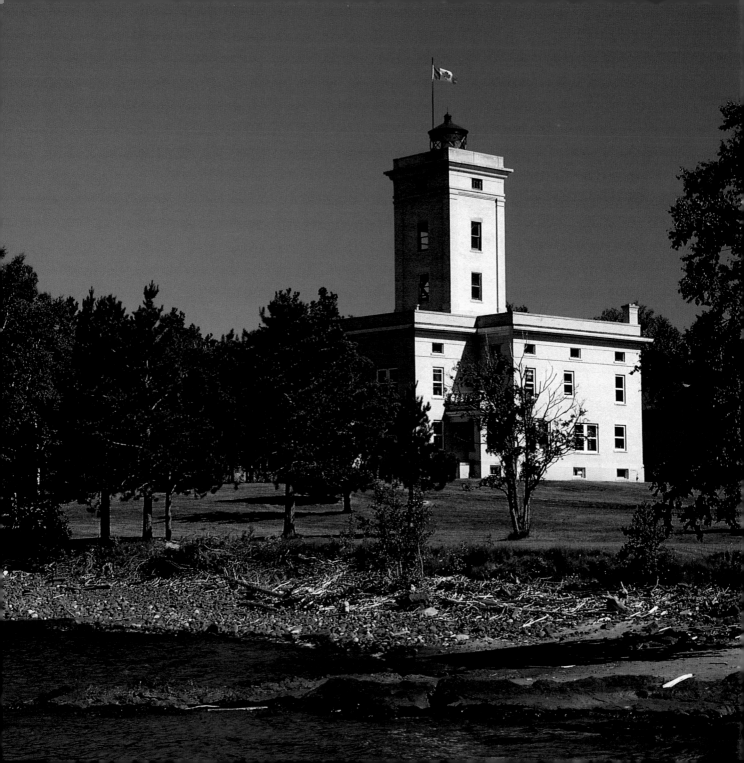

Sand Hills

MICHIGAN

This lighthouse, also known as the Five Mile Point Lighthouse, has been privately owned by William H. Frabotta since 1961. Built in 1917, the tower and the keepers' houses made up one of the two last manned lighthouses to be built on the Great Lakes. (The other, Point Abino, was built the same year.) The lighthouse is a large, two-story yellow-brick structure with twenty-seven rooms.

Originally it was designed as a triplex for the lightkeeper and his two assistants. The three wings were built on the north, east and west sides of the large, square, 50-foot (15 m) tower. The east and west wings, which have an identical, but reversed, layout, were a bit smaller than the north wing and were the homes of the two assistants. The large north wing was the keeper's home and faced the lake. All three keeper's dwellings had separate doors into the tower and separate entrances and front porches. The flat roof and second-story balconies with cement balustrades give the lighthouse an Italian appearance. The whole complex cost $100,000. William Richard Bennetts was the only principal keeper at the lighthouse before it was decommissioned in 1954.

The tower, unlike most lighthouse towers, consists of four levels plus the lantern on the top. Each level has a 12-by-12-foot (3.7 by 3.7 m) room. The tower is made of concrete and steel and is faced with yellow brick outside and red brick inside. It reaches three stories above the roofline of the house, and there are one hundred steps up to the lantern. From the ground, the bottom of the lantern is hidden from view by the cement-and-brick wall and railing enclosing the outer gallery.

The round lantern has curved, square glass panels that are set diagonally into solid brass frames. The lantern is topped by a black dome. It used to house a fourth-order Fresnel lens but the lens is now gone. A fifth-order lens has been acquired and has yet to be installed. The lantern room is a marvelous spot for a fantastic view out over Lake Superior, especially during an electrical storm.

The grounds are spacious, with large lawns bordered by a forest of white birch and white pine. The north lawn slopes gently to the rocky shoreline of Lake Superior. West of the house is a yellow-brick oilhouse that still has its original, diagonally placed asbestos shingles. A boathouse on the shore has since been moved to behind the barracks building and converted to a garage.

Behind the house is a building that used to be U.S. Coast Guard barracks. During the Second World War the lighthouse was used as a secret Coast Guard training station and two hundred men were stationed here. Men were bunked everywhere, including in the attics of the three keepers' houses.

This remote area was without hydro until 1988. Even then it came only after much political battling. With hydro, Frabotta started lighthouse renovations, and by 1994 he had four rooms refinished as part of his bed and breakfast complex. He will eventually have eight rooms available for tourists, and wants to make the top tower room a photo gallery depicting the history of the lighthouse.

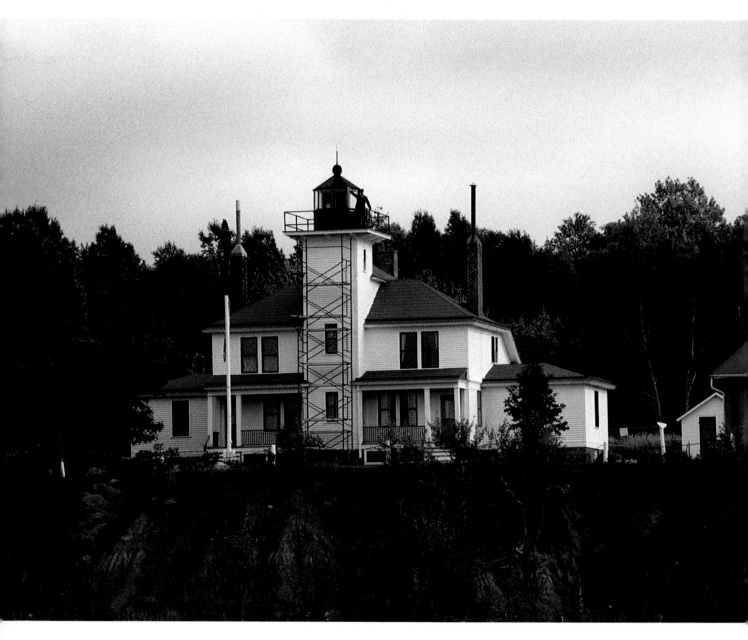

Raspberry Island

WISCONSIN

Before the Sault Canal was built in 1855, shipping on Lake Superior was basically local. Most vessels could not be portaged around the dangerous rapids on the St. Marys River at Sault Ste. Marie. However, after the opening of the locks in 1855, Lake Superior became the last leg of a six-lake, 1,000-mile-long (1,600 km) water shipping route. Trans-lake shipping increased with a new influx of lumber, brownstone, grain and iron ore, and many places on Lake Superior became busy shipping ports. One such place was Bayfield, located on the southeast shores of the Bayfield Peninsula, near the Apostle Islands.

Congress authorized a light to be built on Long Island to mark the south channel shipping lane to Bayfield. The lighthouse was finished in 1857; however, the builder had the wrong island, and so Michigan Island had a lighthouse. To correct his error, the builder built a second lighthouse on Long Island at his own expense. La Pointe lighthouse was completed in 1858, at which time the Michigan Island lighthouse was extinguished.

Lake traffic continued to increase, and in 1863 a lighthouse was built on the southwest side of Raspberry Island to guide ships through the western channel to Bayfield. The Raspberry Island lighthouse is one of the seven lighthouses on the twenty-two Apostle Islands. As lake traffic continued to expand, the lighthouse on Michigan Island was repaired and relit in 1869. New lighthouses were constructed on Outer Island (1874), Sand Island (1881) and Devil's Island (1891), and a second, Chequamegon Point (1895), on Long Island. These seven lighthouses on six islands make the greatest concentration of lighthouses in the United States.

The lighthouse on Raspberry Island was requested in 1859, but construction was not complete until 1863. It sits 40 feet (12 m) above Lake Superior on a clay bluff on the southwest side of the island.

The square-frame tower with white clapboard siding rises about three stories and is topped by a large square gallery surrounded by a black iron railing. The two-story keeper's dwelling is a duplex and flanks the tower symmetrically on both sides. The decagonal lantern housed a fifth-order Fresnel lens. A bright, white flash was emitted every ninety seconds. The Fresnel lens was removed in 1952 and is now in the Madeline Island Museum.

A fog-signal building was constructed of red brick in 1902, housing a 10-inch (25 cm) steam whistle as well as a hoisting engine for the recently built tramway. In 1928 a diesel-driven electric generator was installed, and in 1933 the steam whistle was replaced with a diaphone. In 1947 the Raspberry Island Light was fully automated. In 1952 the Coast Guard discontinued the fog signal and replaced the light with a smaller one on a metal tower.

Today, all the lights on the Apostle Islands are automated. The Coast Guard services the lights and navigation aids while the Parks Service maintains the buildings and grounds. Each year the Apostle Islands National Lakeshore chooses volunteer keepers to live at the lighthouses, give guided tours and do small maintenance jobs.

The Raspberry Island Lighthouse may be visited by taking the Apostle Island Cruise. Visitors land at the island dock, climb the bluff and receive a guided tour of the tower and the house, which is operated as a museum.

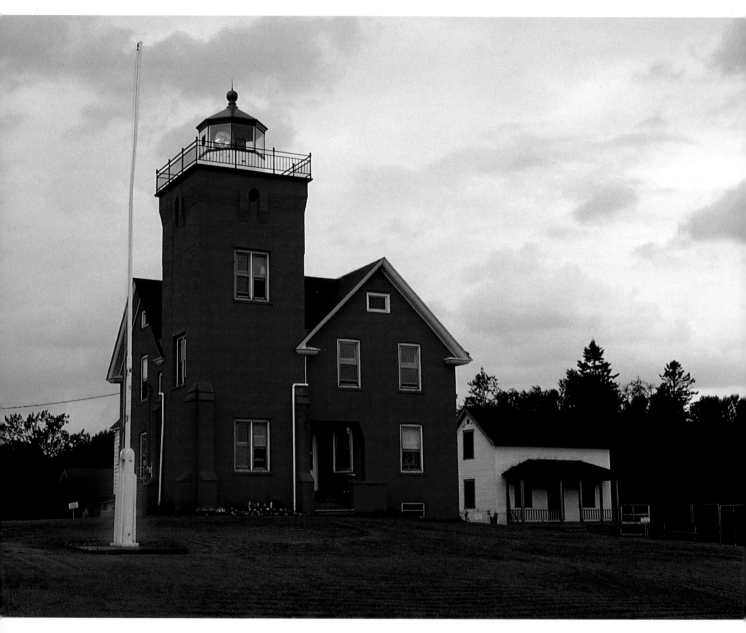

Two Harbors

Two Harbors has been a commercial fishing town since 1857. The Ojibwa name for this location is Wasswewining, meaning "a place to spear fish in the night." As Superior's fish supply lessened, Two Harbors began to export taconite, a crude form of iron ore. Busy lake traffic made it necessary to build the light in 1892. At the turn of the century, about a hundred boats per week entered the harbor. Today about six ore carriers arrive each week to carry the ore out.

Construction of the lighthouse was started in 1891 and the light was first lit on April 4, 1892. It is 49 feet 6 inches (15 m) tall from its base to the top of its ventilator ball, but with its location high on the hill, it sits 78 feet (24 m) above the lake. Today it is Minnesota's last working lighthouse. The U.S Coast Guard owns the land and maintains the light. The light station has been fully automated and was first unmanned on August 18, 1982. The Lake County Historical Society started restoration of the lighthouse and buildings in 1990. They continue to gradually restore the buildings to their original condition using antiques of the period.

The tower is open to the public, but the four-bedroom lightkeeper's residence is privately lived in. Originally there were three keepers here. The third was on call, and when he worked, he lived in the tiny, first-floor room of the tower. The first lightkeeper was Charles Lederle.

The keeper's dwelling is a stately two-and-a-half-story, redbrick house, built against two sides of the square tower. The walls of the house are two layers of brick thick; the tower is three layers thick. As part of the restoration, the brick has been painted red and the building has been trimmed in white. There are double windows up the sides of the tower and ornate brickwork frames the round windows in the watchroom below the lantern.

The tower has forty steps ascending in a narrow staircase that winds up the outside walls through four levels to the lantern. The first level has the spare room for the assistant lightkeeper. There is no room at the second level, as it is just a partial landing. The third level has the lightkeeper's office. On the fourth level are four porthole-style windows to help ventilate the lantern. A ladder leads up to the octagonal lantern. Six sides are glazed and two are closed in. A square outside gallery with a black iron railing surrounds the white lantern, which is topped by a red dome and a ventilator ball.

The original light had a fourth-order Fresnel lens with an oil-and-wick light. Later a kerosene light with about 30,000 candlepower was used. Weighted chains had to be reset every two hours to turn the lens. In 1921 electric light was installed. The new light had 230,000 candlepower. In 1970 the Fresnel lens was replaced with an electronic beacon. There are two 1,000-thousand-watt lightbulbs in each of the two 24-inch (61 cm) beacons that rotate in the tower, giving a visibility of 17 miles (27 km).

Outbuildings include the oil house, storage buildings, the assistant keeper's house, the fog-signal house (which housed two steam compressors — one for backup) and a restored pilot house from the *Frontenac* (a wrecked iron-ore boat). The assistant lightkeeper's house is restored to its turn-of-the-century state. It is a small, white, two-story frame house with a cedar-shake roof and gray trim. Originally a barn, it was moved to the site in 1894.

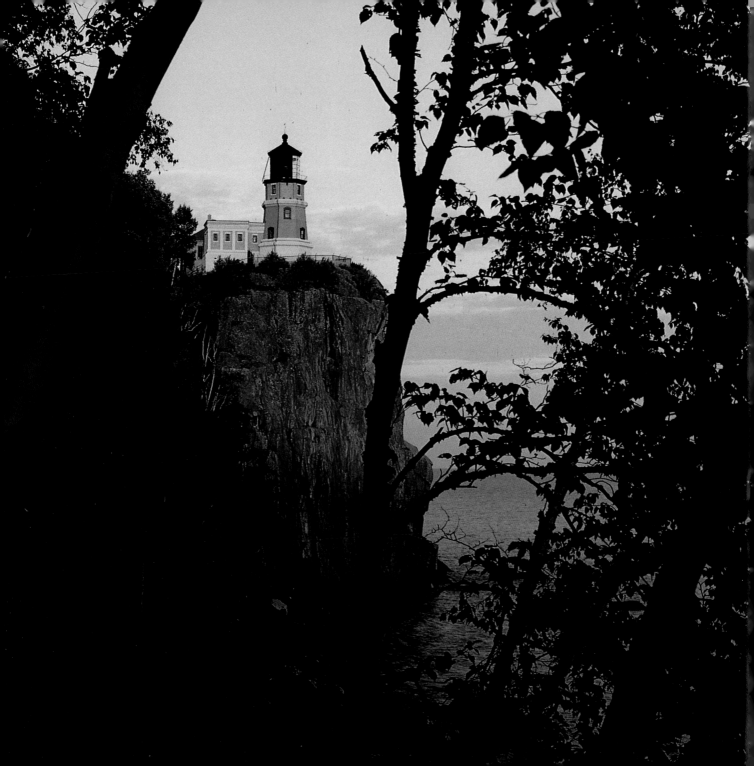

Split Rock

MINNESOTA

Split Rock lighthouse is probably the best-known and most frequently visited lighthouse on the Great Lakes. It is located at the top of a 100-foot (31 m) rock cliff on the north shore of Lake Superior. Split Rock Point was a particularly dangerous area for ships. Not only did ships have to contend with the severe storms of Lake Superior, but they also had to deal with the iron-ore ranges, which would throw off their compasses.

In 1907 Congress appropriated $75,000 for a lighthouse and fog signal. Construction began in the spring of 1909. First a derrick and a hoisting engine were installed at the top of the rock cliff to hoist up building materials, equipment and supplies. During the first summer they built the keeper's house, the oil house and the storage barns. The fog-signal building and the light tower were built the next year. The light was first lit on August 1, 1910. Its visibility was officially 22 miles (35 km) but it could often be seen much farther away.

The first lightkeeper here was Orren "Pete" Young, who served from 1910 to 1928. The first assistant lightkeeper, Franklin J. Covell, became lightkeeper in 1928.

All the buildings are made from yellow brick. The tower is only 38 feet (11.7 m) tall, but because it is on a cliff, it sits 168 feet (51.7 m) above Lake Superior. Inside the unique octagonal tower is a circular iron staircase with a hollow post in the middle called the weightway. (The weights that powered the turning mechanism descended through this.) The circular walls inside are glazed enamel for easier daily cleaniong. The watchroom at the base has four windows that overlook the lake. From here the lightkeepers could watch for approaching ships and changes in the weather. There was also a window in the weightway so that the lightkeeper could watch for the descending weights, which had to be rewound every two hours.

The lantern has sixteen panels. The nine panels facing the water have twenty-seven panes of curved, green-tinted glass. The seven back panels are steel. The central attraction of this room is the original third-order Fresnel lens, which has a gear box attached to its base, from which the weights are suspended. The lens floats in 250 pounds (113.6 kg) of mercury, making it possible for the lens to turn fast enough so that only two lens panels are necessary to produce the required signal of one flash every ten seconds. The light inside the lens was an incandescent oil-vapor light.

The fog-signal house had two roof horns, which sounded two seconds out of every twenty during an emergency. In 1961 the fog signal was removed, as it had become obsolete.

By the early 1930s about 5,000 people per year visited the light station. The station was closed in 1969 and is now a part of the Split Rock State Park and is operated by the Minnesota Historical Board. Today the museum and lighthouse receive about 100,000 tourists every year.

The Split Rock Lighthouse was among the five lighthouses honored on commemorative stamps in the summer of 1995.

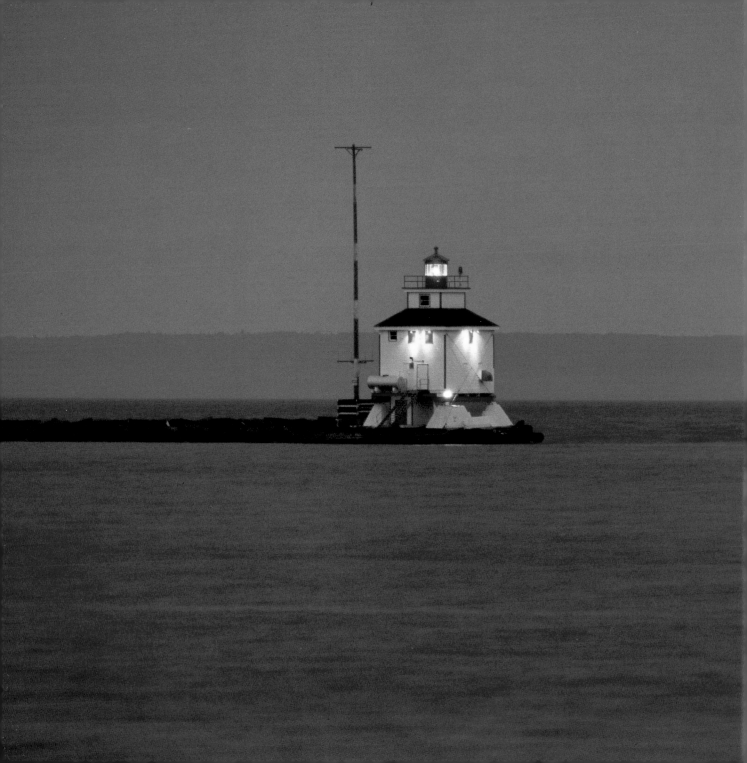

Thunder Bay

ONTARIO

Thunder Bay is located near the west end of Lake Superior. The first steamer to dock there was the *Algoma*, on May 16, 1868. It carried men and mining machinery into the area. In the summer of 1868, a general store, a restaurant and the first business docks were built. The *Algoma* continued semimonthly trips between Collingwood and Thunder Bay to bring in supplies. In 1873 the steamer *Erin* transported 10,000 bushels of wheat, the first of many loads to be shipped from Western Canada.

In 1882–83 the Canadian Pacific Railway extended the docks and built the first lighthouse on the southeast corner of the dock. Later, large breakwaters were built out into the lake to help make a safe harbor. A new lighthouse was constructed in 1937 at the end of the breakwater on the north side of the central entrance.

This main lighthouse is white with red trim and it sits 48 feet (15 m) above the water. Unlike other lighthouses, it sits on four pyramid-shaped cement supports on top of a storage room that fits snugly between the cement corners. The light tower is square and juts up about 4 feet (1.2 m) out of the roof of the main, square building below. An iron handrailing around the outer walkway surrounds the octagonal lantern. The lighthouse has a red flashing light that flashes every five seconds with a 12-mile (19 km) visibility. The illuminating apparatus is catoptric and is electrically powered.

Looking away from the harbor, you can see a large peninsula of land in the distance. According to native legend, Nanabosho (the Giant), the son of Kabeyun (the West Wind) led the Ojibwa to the north shores of Lake Superior where they would be safe from their enemies, the Sioux. The Ojibwa discovered silver here, but Nanabosho was afraid for his people, so he made them bury it. A few days later, Nanabosho saw a Sioux warrior canoeing across Lake Superior with two white men. He assumed it was to show them the location of the silver. Nanabosho wished to protect his people by keeping the location of the silver a secret. He raised a storm, which caused the men to drown, but by doing this he disobeyed the Great Spirit. The Great Spirit turned him to stone as punishment. Today Nanabosho lies where the Great Spirit struck him down, and that is why this peninsula is known as the Sleeping Giant.

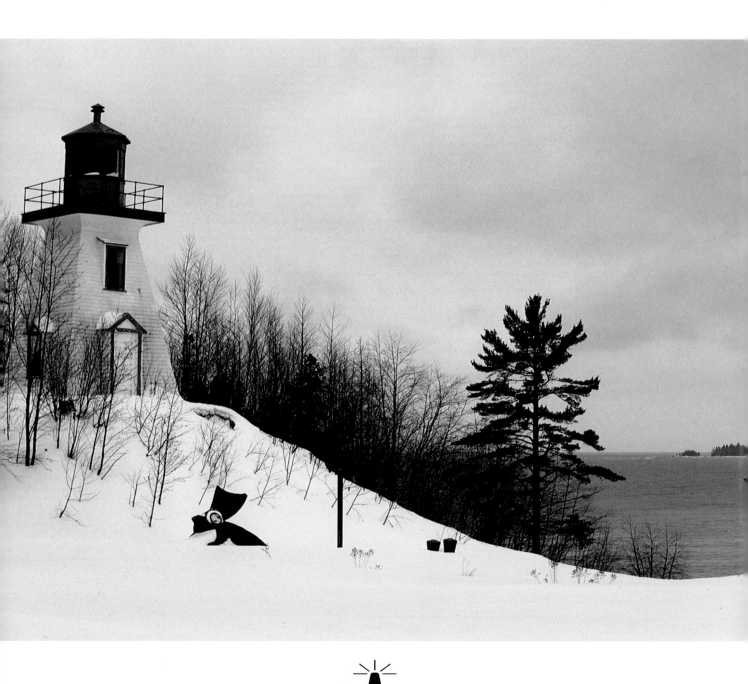

Coppermine Point

ONTARIO

At one point Coppermine Point lighthouse was almost torn down. The Canadian Coast Guard contracted Ernie Demers to demolish the lighthouse, probably to save themselves the cost of upkeep. However, Ernie felt it would be a shame to have this historic monument become firewood. So, with the aid of John Helm and a large crane, the lighthouse was carefully dismantled and moved to its present location on the Trans-Canada Highway, 60 miles (100 km) northwest of Sault Ste. Marie.

BIBLIOGRAPHY

Bacon, Betty Bynes. *Lighthouse Memories*. Bay Mills: Brimley Historical Research Society, 1989.

Beaubien, Conrad. *Sketches of Our Town*. Town of Kincardine. Videocassette.

Canadian Coast Guard. *Inland Waters: List of Lights, Buoys and Fog Signals*. Ottawa: Marine Navigation Services, 1992.

Chenning, Jay. "Architecture of the City of Dunkirk."

Fred Coyne. "The Valley of the Lower Thames." 1951.

Gibson, Sally. *More Than an Island*. Toronto: Irwin Publishing, 1977.

Great Lakes Lighthouse Keepers' Association. "Great Lakes Lighthouses." *Beacon* 13, 2, 1995.

Hall, Stephen. *Split Rock: Epoch of a Lighthouse*. Split Rock: Minnesota Historical Society, 1987.

Hatcher, Harlan. *A Pictorial History of the Great Lakes*. New York: Bonanza Books, 1963.

Henry, Anne M. "The Early History of Sodus Light Station."

Holland, Francis Ross Jr. *America's Lighthouses*. New York: Dover Publishing, 1988.

Keweenan County Historical Society. *Ten Lights*. Eagle Harbour: Keweenaw County Historical Society.

Lauriston, Victor. *Romantic Kent: The Story of a County*. Chatham: Shepherd Printing Co., 1952.

Manitoulin Tourist Association. "Lighthouses on Manitoulin Island."

Metcalfe, Willis. *Canvas and Steam on Quinte Waters*. Picton: Prince Edward Printing, 1993.

Miller, Ken. "*The Old Lighthouse at Presque Isle*." *Great Lakes Cruiser,* 1, 10. Royal Oak: Great Lakes Cruiser Ltd., 1994.

Northcott, Bill. *Thunder Bay Beach*. Erin: Boston Mills Press, 1989.

Penrose, Laurie. *A Traveller's Guide to 100 Eastern Great Lakes Lighthouses*. Davison: Friede Publications, 1994.

———. *A Traveller's Guide to 116 Michigan Lighthouses*. Davison: Friede Publications, 1993.

———. *A Traveller's Guide to 116 Western Great Lakes Lighthouses*. Davison: Friede Publications, 1995.

Pomeroy, Scarlett. *Back Roads*. Buchanan: Scarlett Pomeroy, 1993.

Regnier, Kathleen. "Boardwalk Protects Ridges, Links Range Lights." *Door County Advocate*, July 21, 1995.

Remick, Teddy. *Treasure of H.M.S. Ontario*.

Ribey, Barbara. "Point Clark Light Keeper's House." Point Clark Light Keeper's Museum.

Tinney, James. *Seaway Trail Lighthouses*. New York: Seaway Trail Inc., 1989.

United States Department of Agriculture. "Point Iroquois Light Station."

Vandeweghe, W.R. "The Old Thames River Lighthouse." 1973.

Weeks-Mifflin, Mary. *Harbour Lights: Burlington Bay*. Erin: Boston Mills Press, 1989.

———. *The Light on Chantry Island*. Erin: Boston Mills Press, 1986.